JACK VETTRIANO

WOMEN IN LOVE

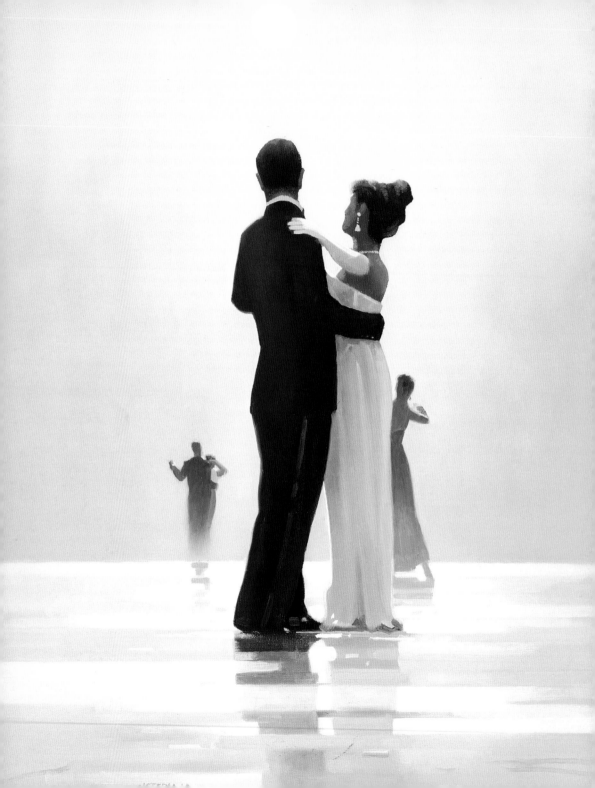

JACK VETTRIANO

WOMEN IN LOVE

PAVILION

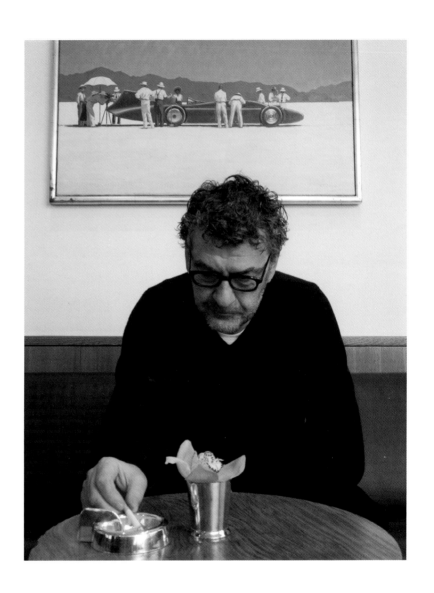

Previous Page: Dance Me To The End of Love

love

- noun

1 an intense feeling of deep affection.
2 a deep romantic or sexual attachment to someone.

I have always sought the company of women over men. This is not purely a sexual endeavour; as companions, they possess a range of qualities that far outweigh those of mere man.

In choosing the paintings for *Women In Love*, I have purposely avoided my femme fatales and their compulsive yet compelling manipulative behaviour. I have chosen those paintings which I think best illustrate my definition of love and contain the aspects of women that draw me in.

'All the rocket ships are climbing through the skies,
the holy books are open wide,
the doctors working day and night,
but they'll never ever find a cure for love.
Ain't no cure for love.'
('Ain't no cure for love' by Leonard Cohen)

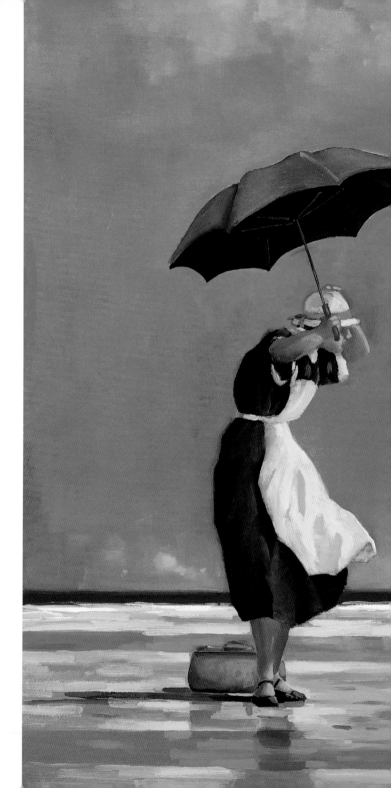

The Singing Butler

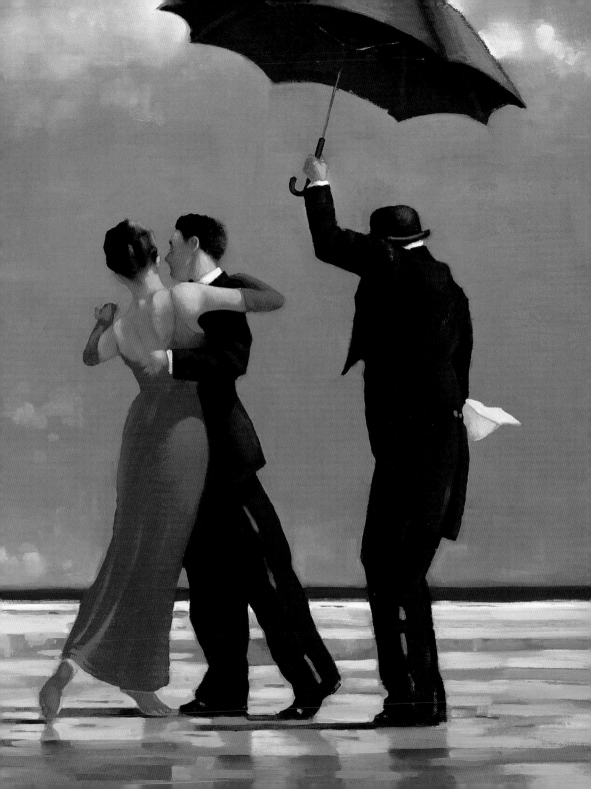

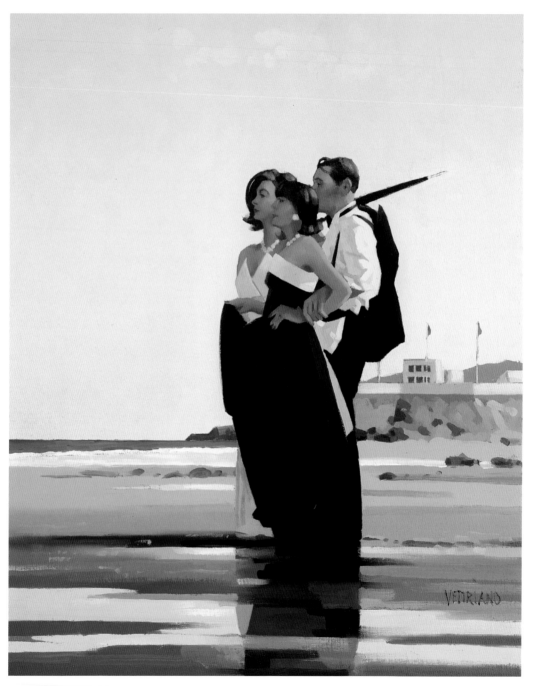

The Missing Man

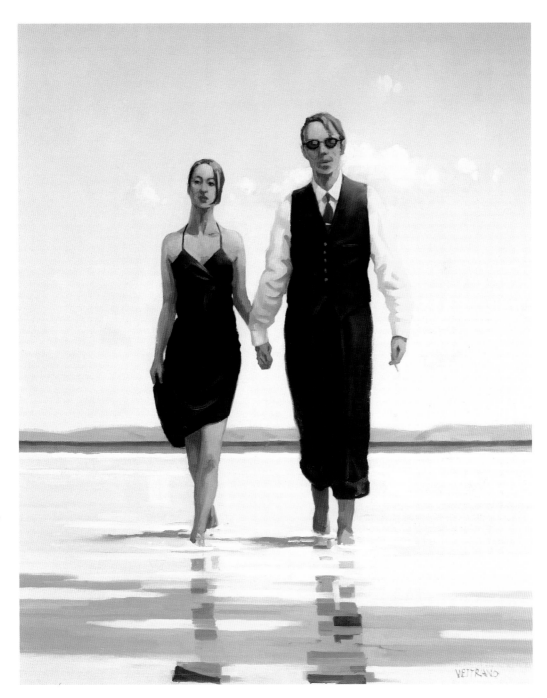

Tender Hearts

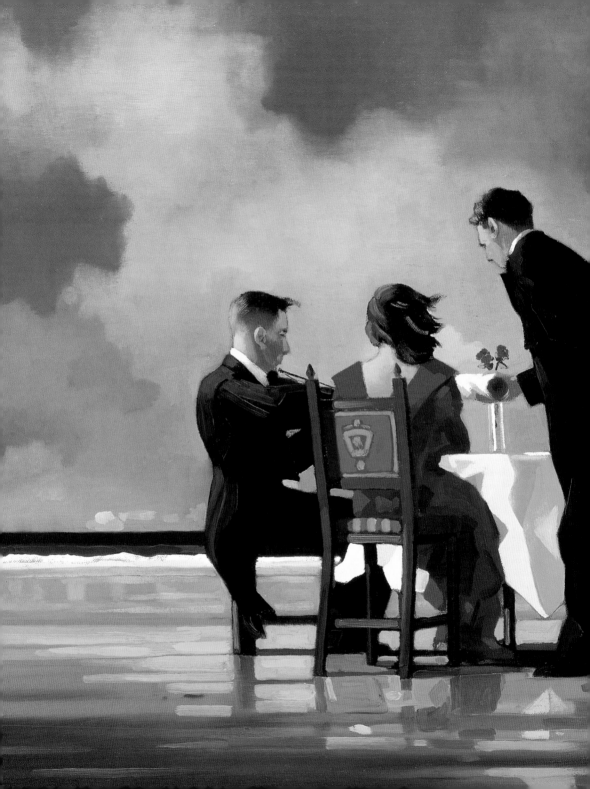

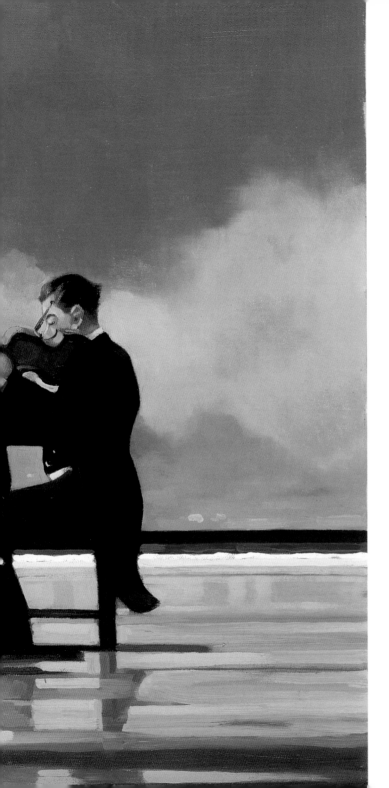

Elegy for the Dead Admiral

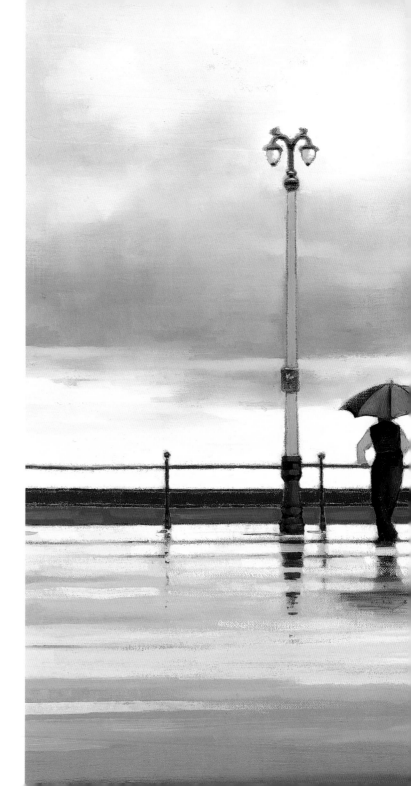

The Shape of
Things to Come

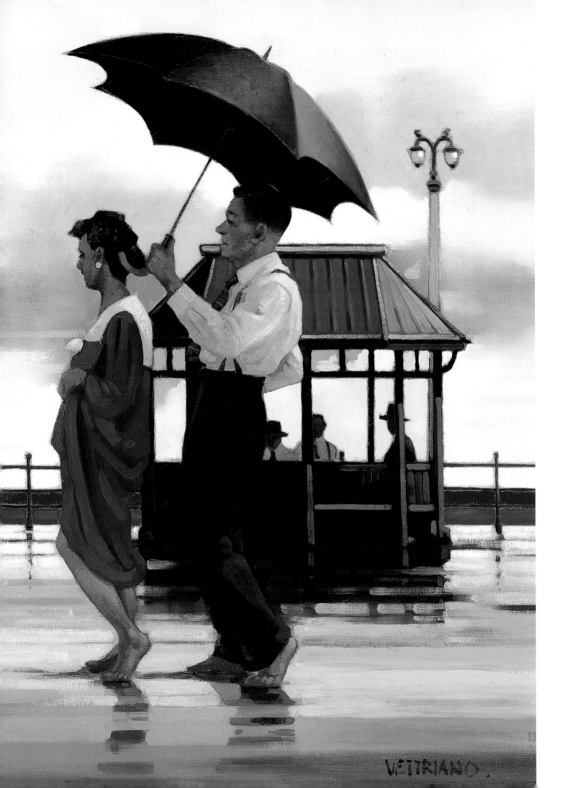

VETTRIANO.

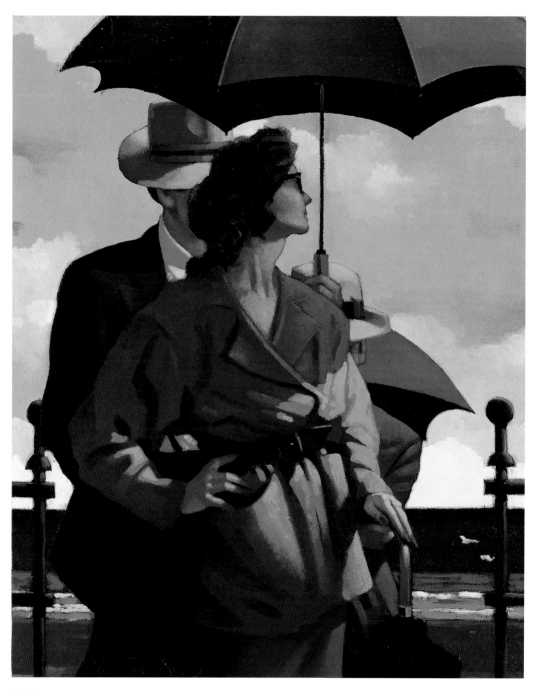

Right Time Right Place

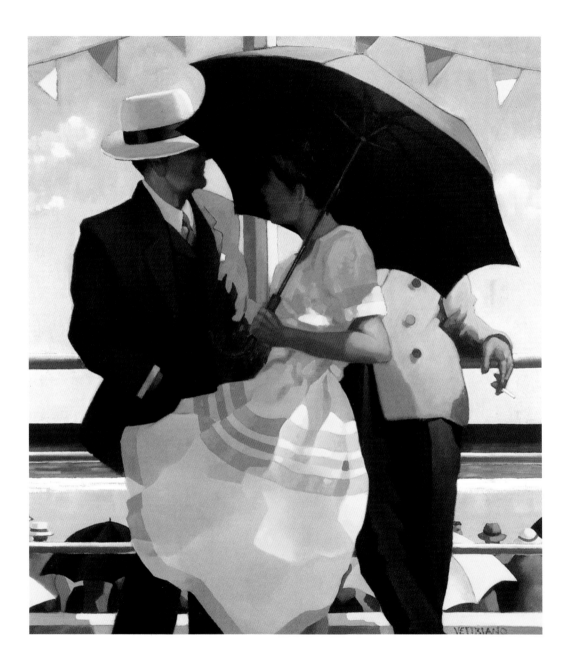

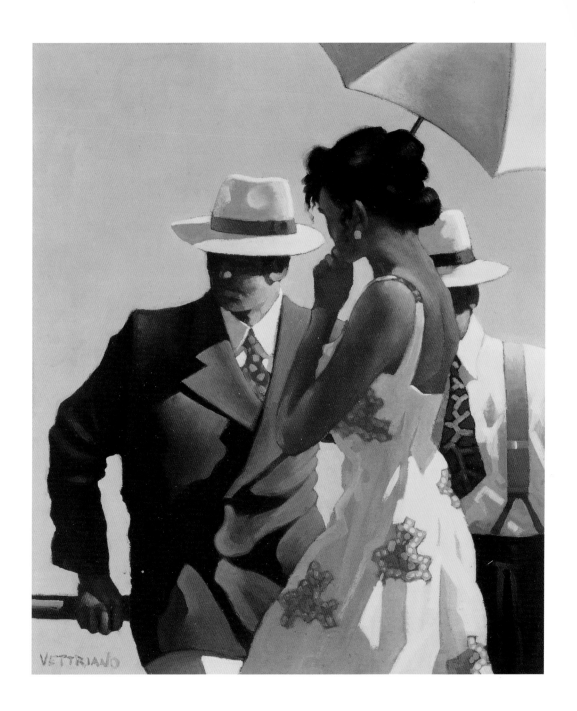

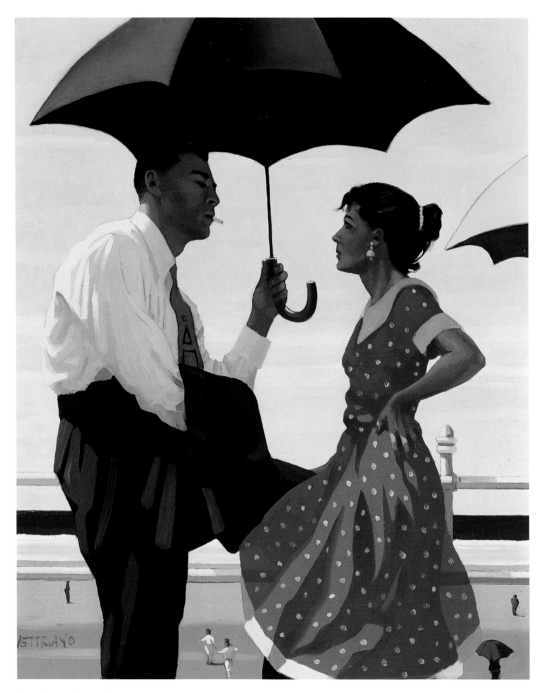

Bad Boy, Good Girl

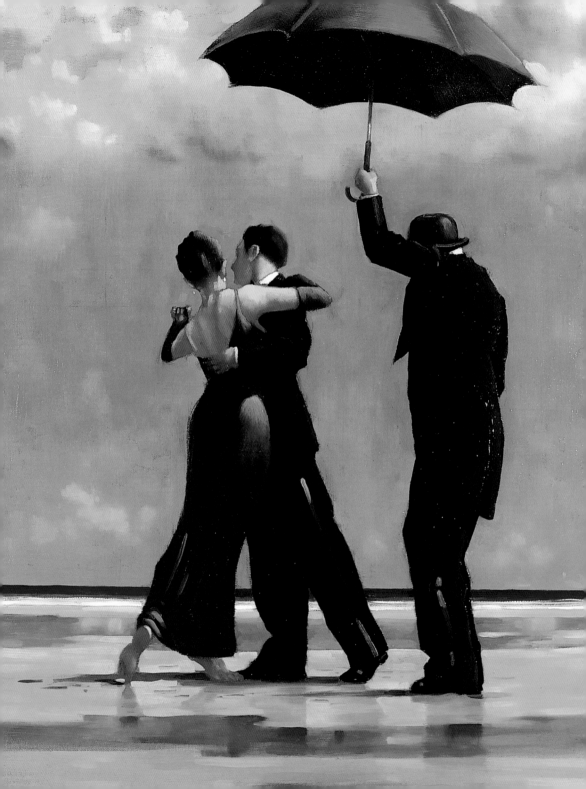

Dancer in Emerald

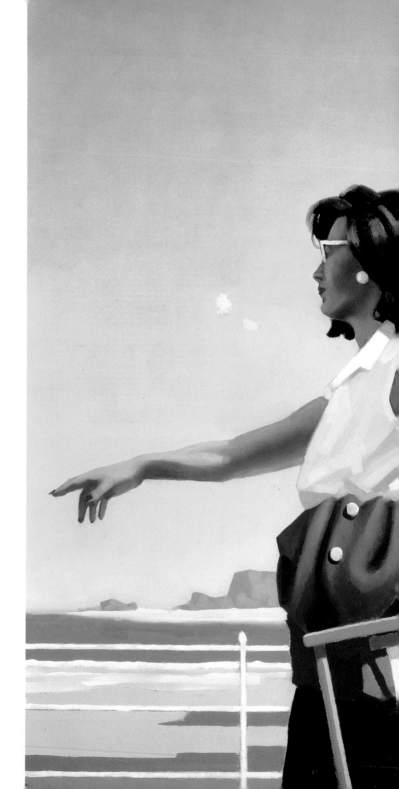

The Sun Worshippers

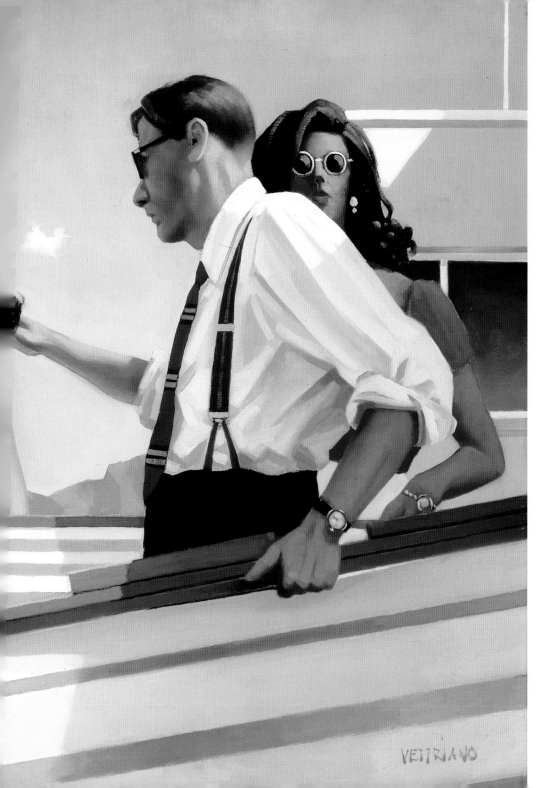

VETTRIANO

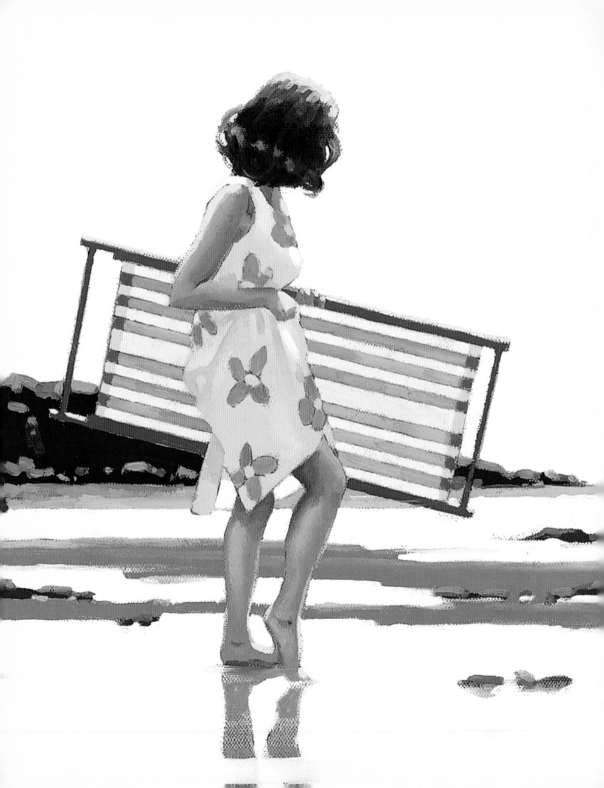

Sweet Bird of Youth (Study)

Sweet Bird of Youth

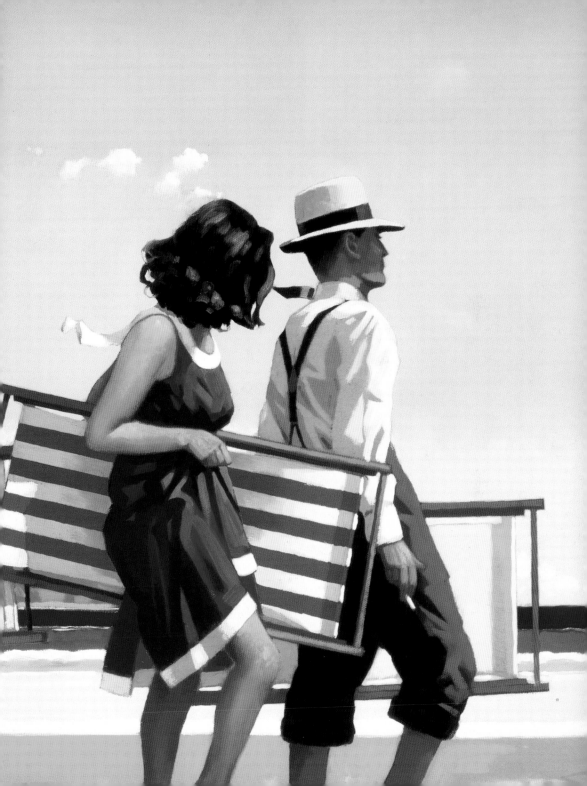

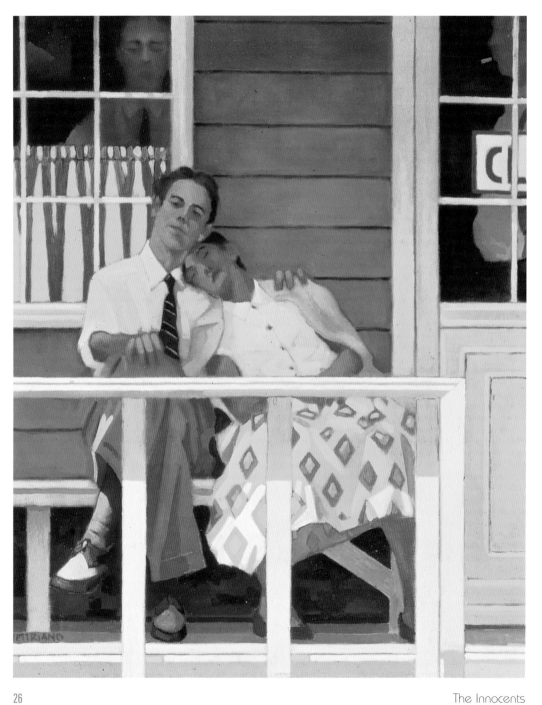

The Innocents

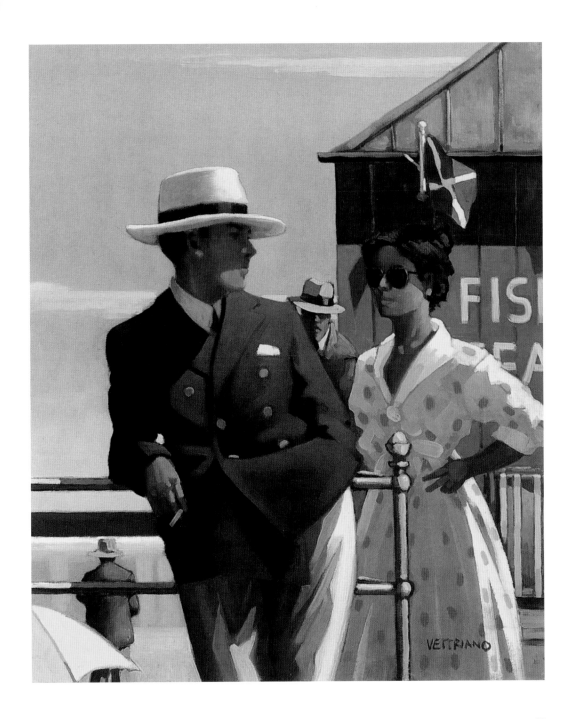

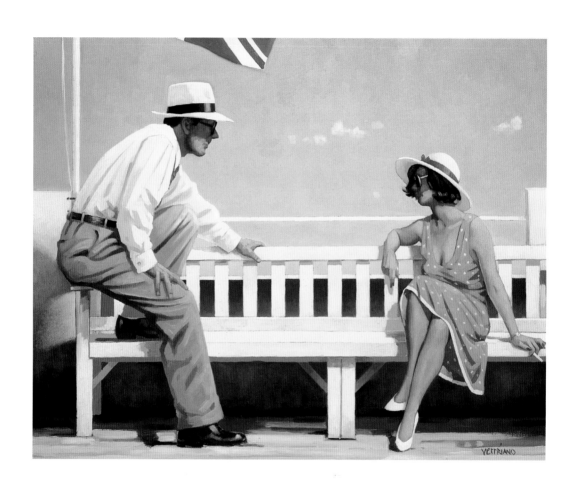

Mr Cool

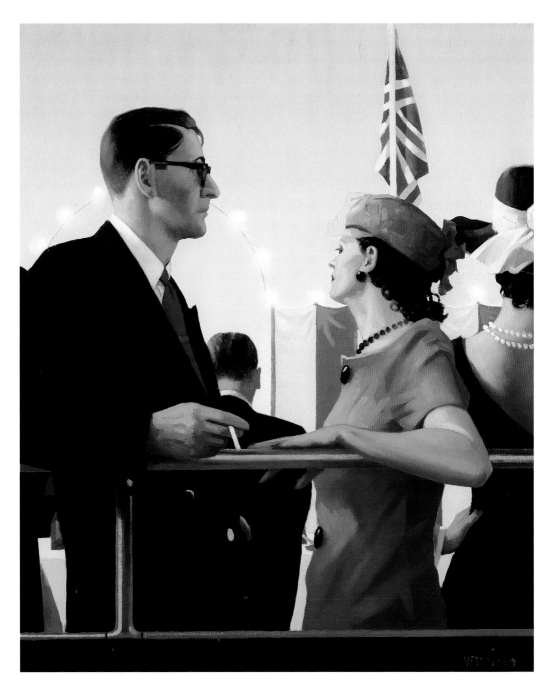

A Day at the Races

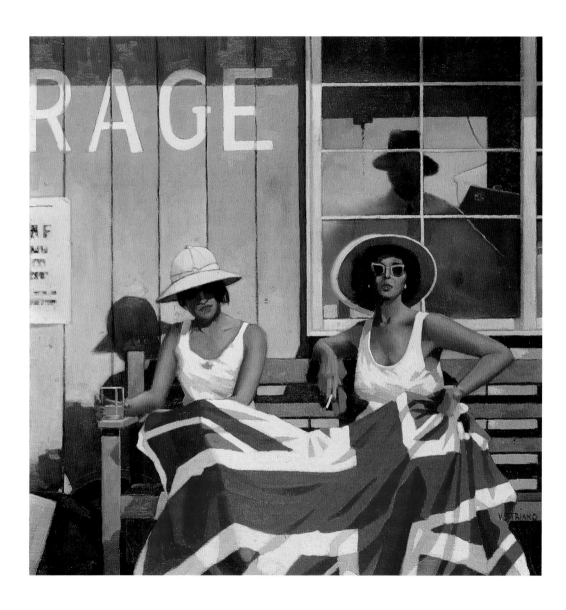

The British Are Coming

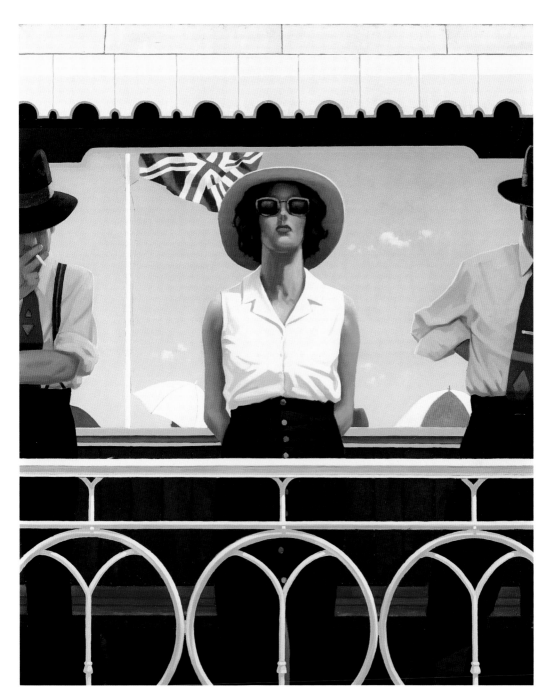

Bird On The Wire

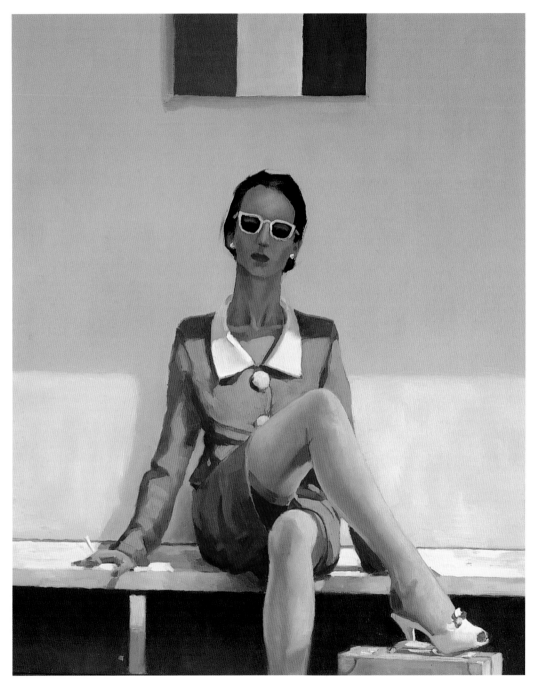

The Tourist

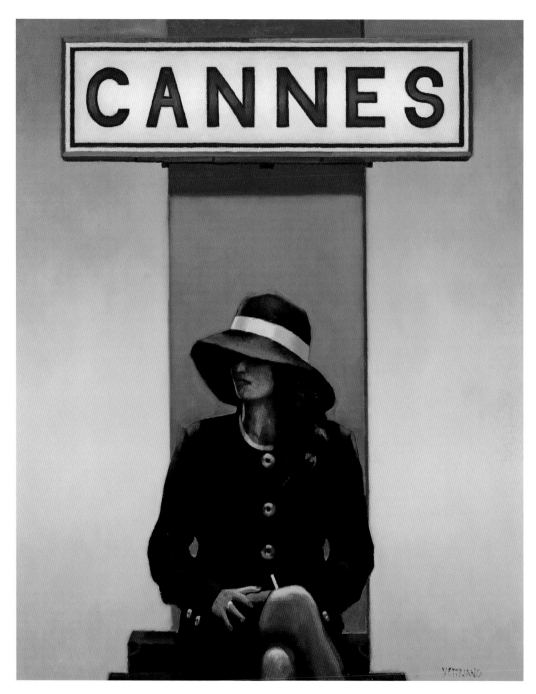

Exit Eden

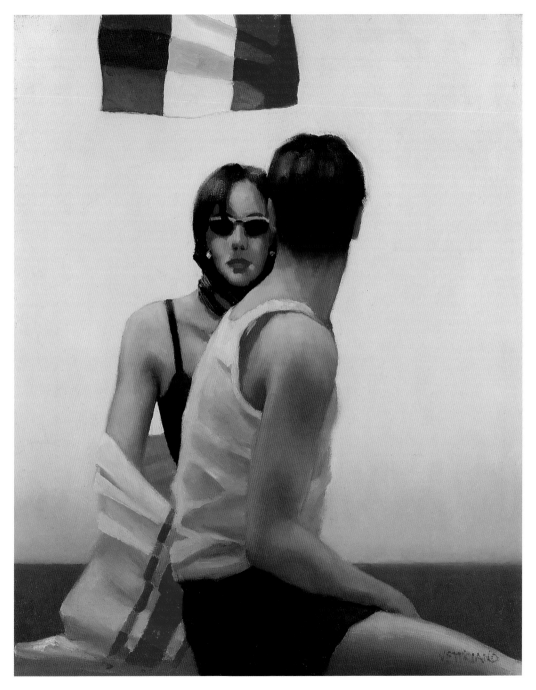

Riviera Retro

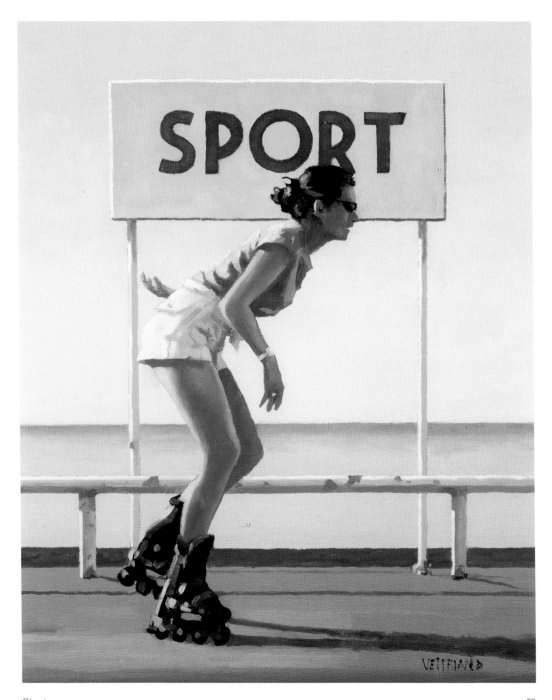

Blades

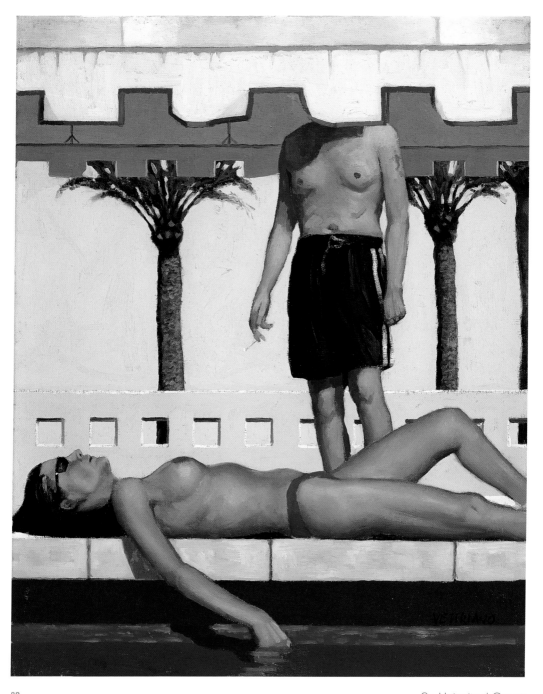

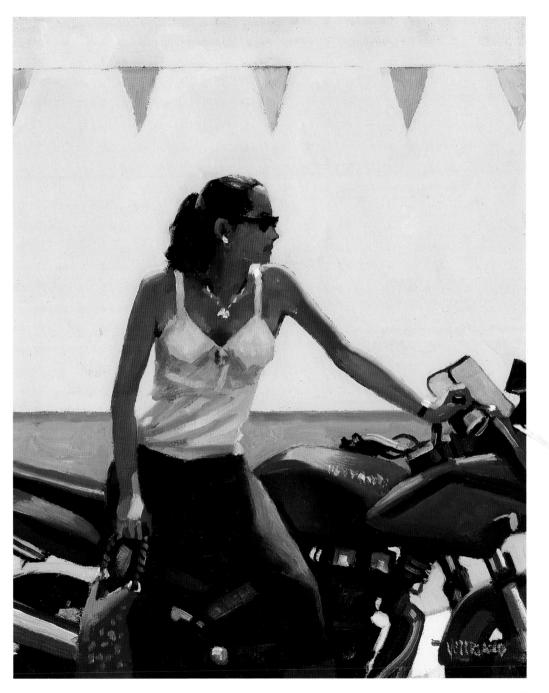

La Fille à la Moto

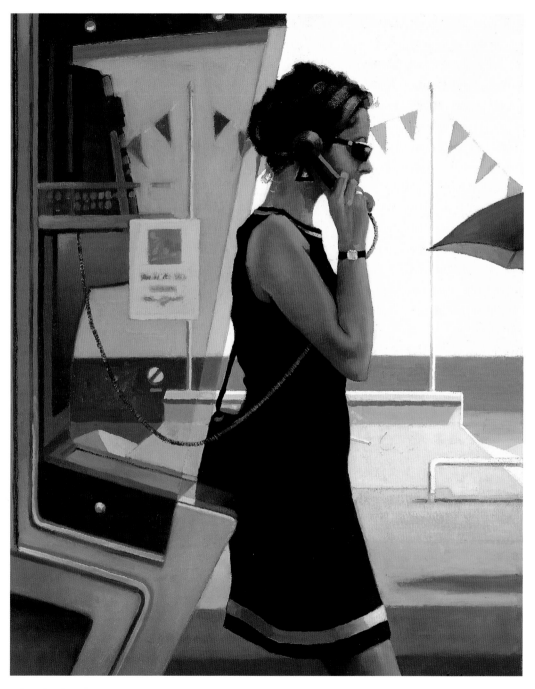

Her Secret Life

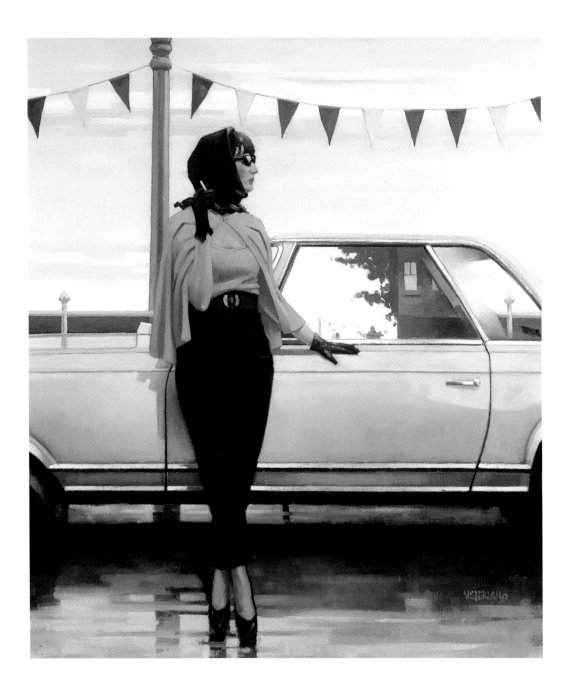

Suddenly One Summer

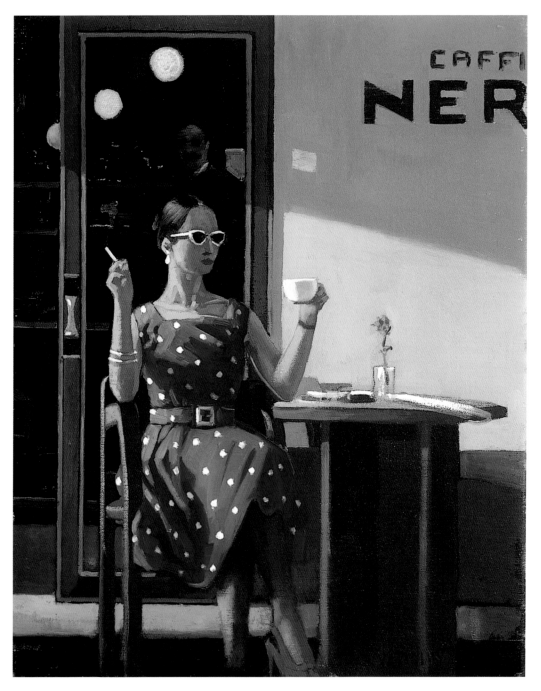

The Ice Maiden

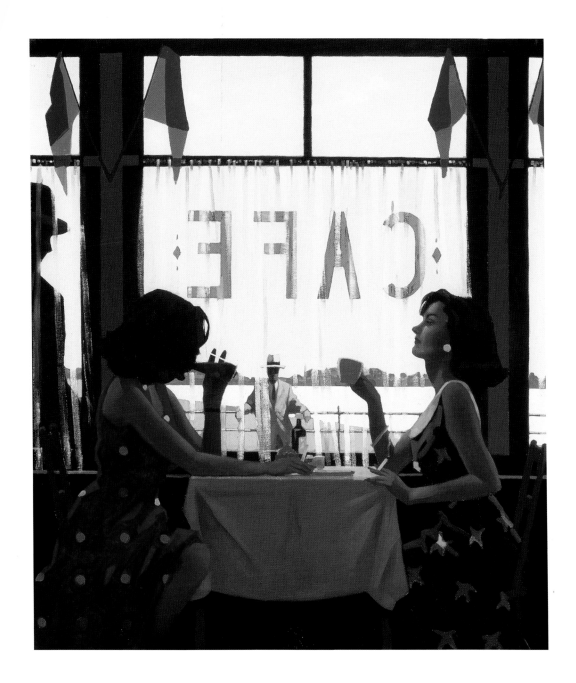

Café Days

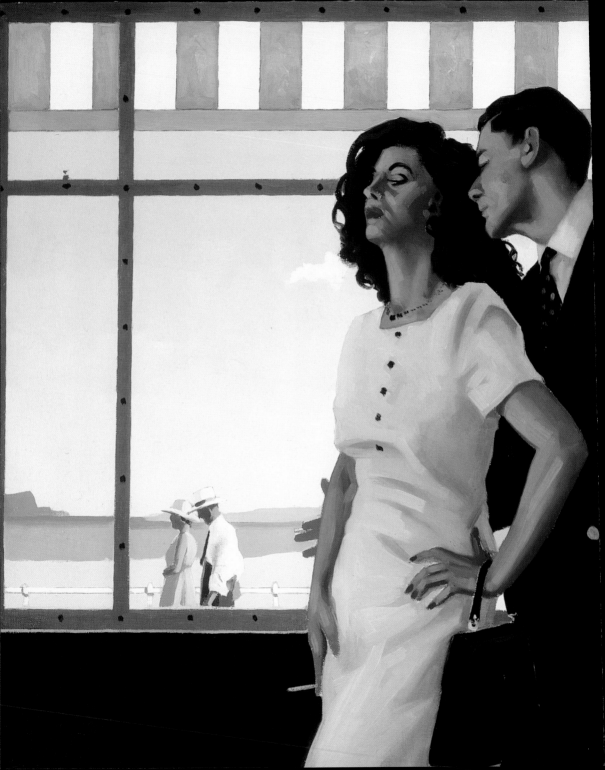

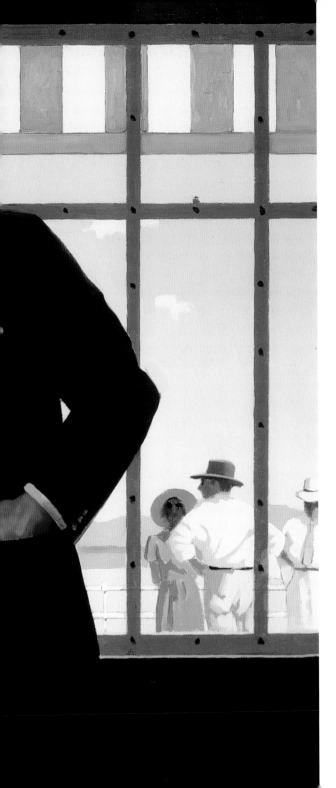

The Man in the Navy Suit

Lunchtime Lovers

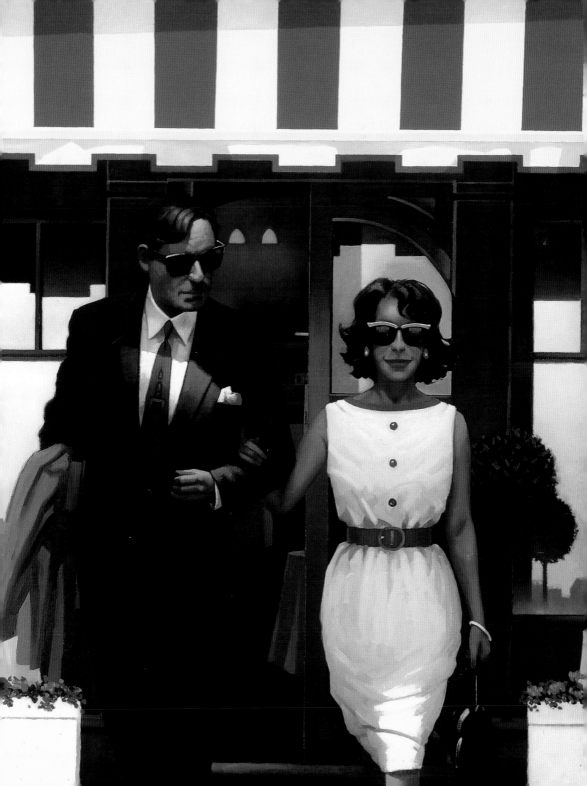

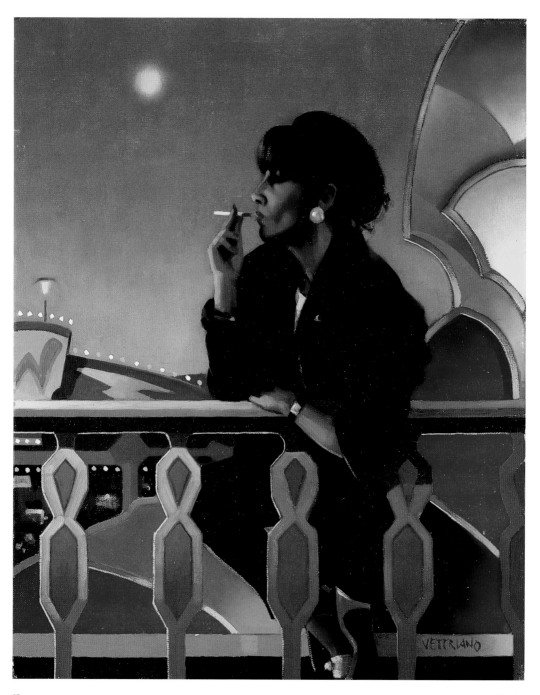

Birdy

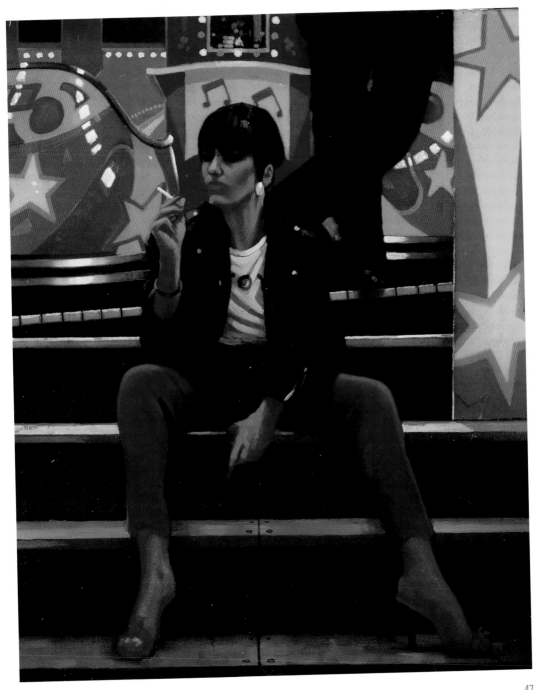

Queen of the Waltzer

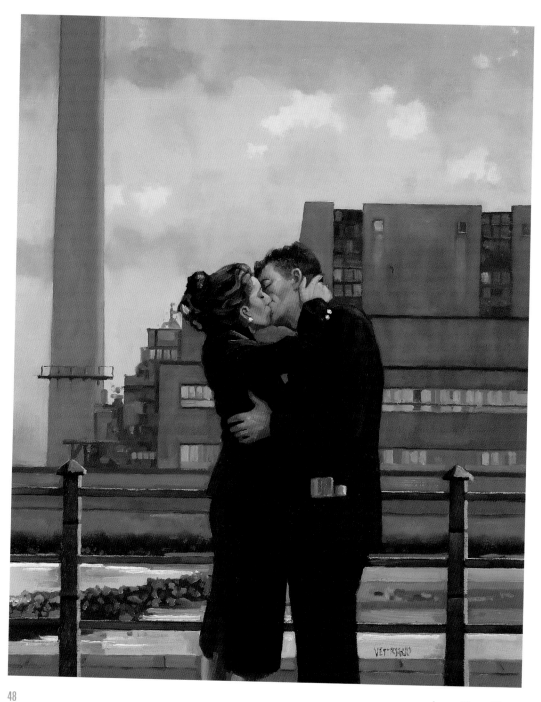

Long Time Gone

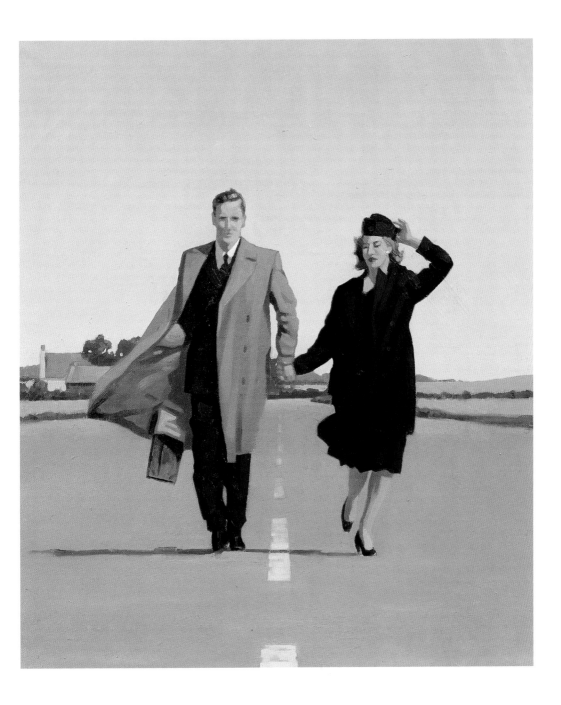

The Great Escape

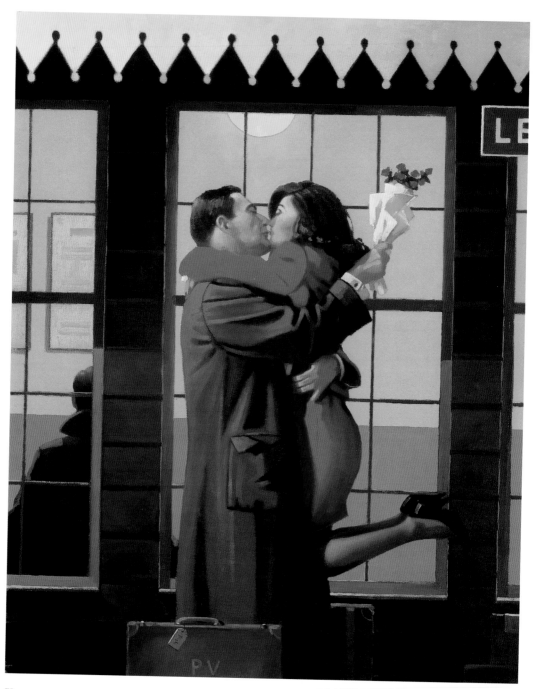

Back Where You Belong

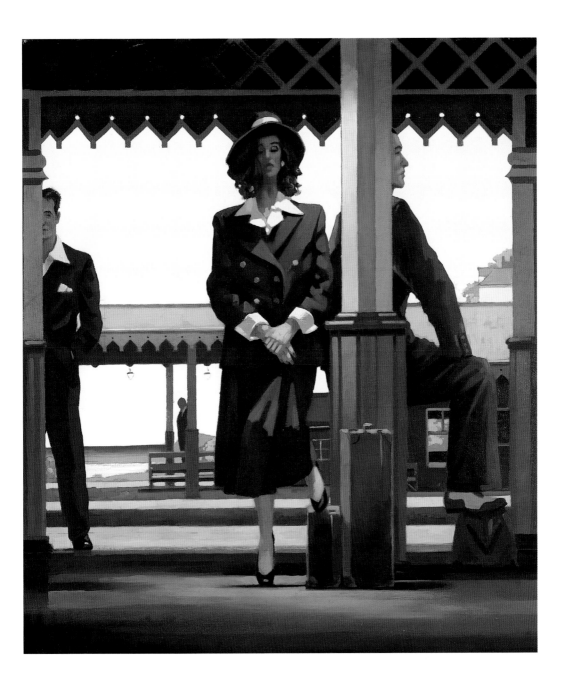

The Railway Station

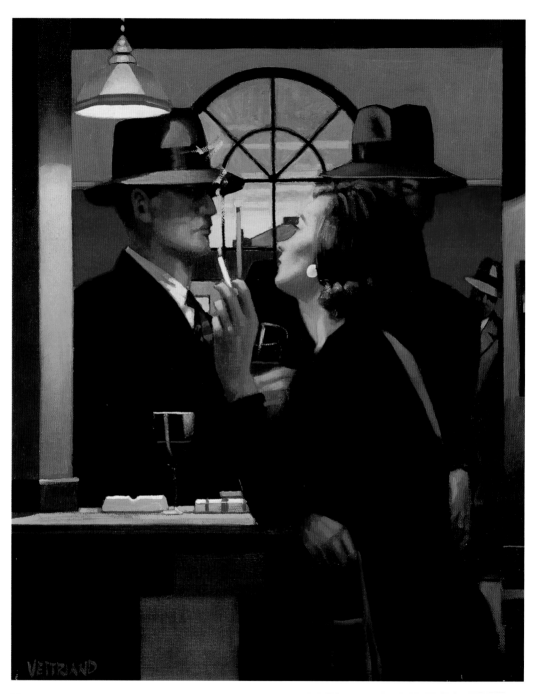

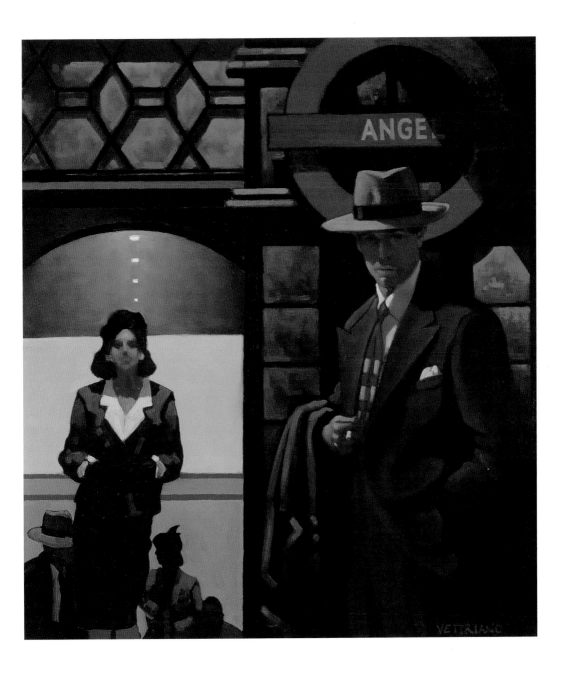

Angel

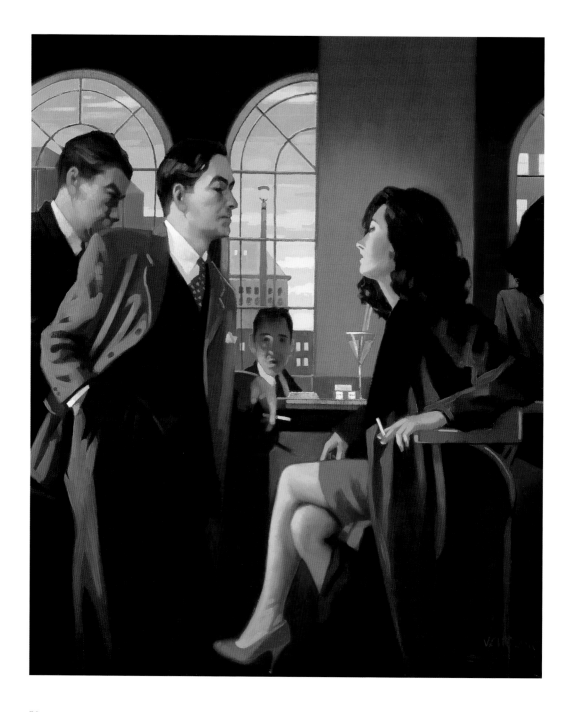

The Red Room

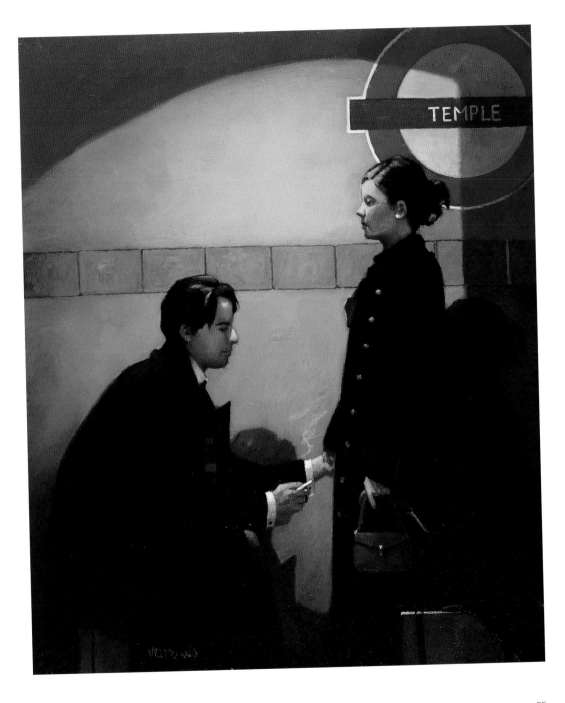

The Runaways

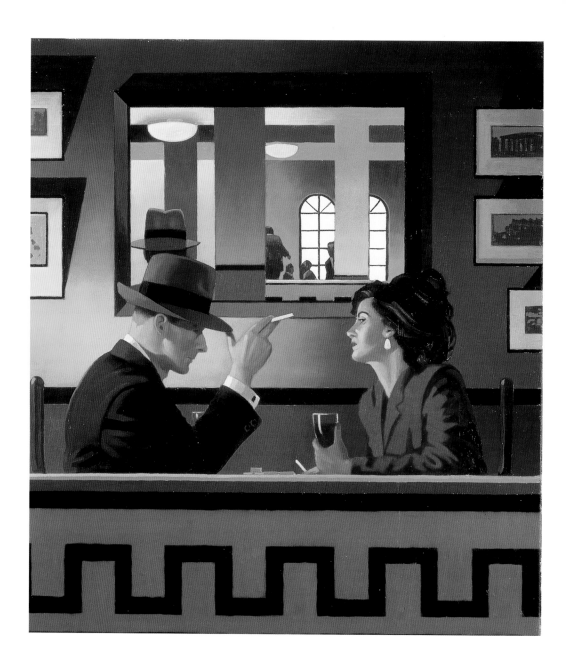

56

The Man in the Mirror

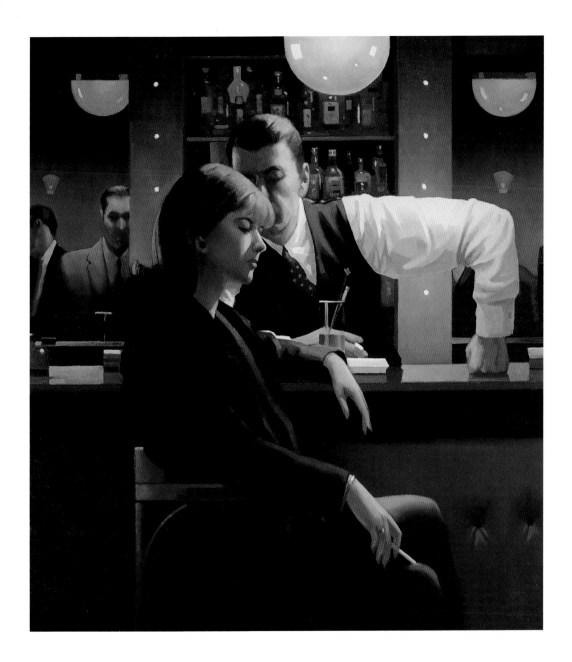

Cocktails and Broken Hearts

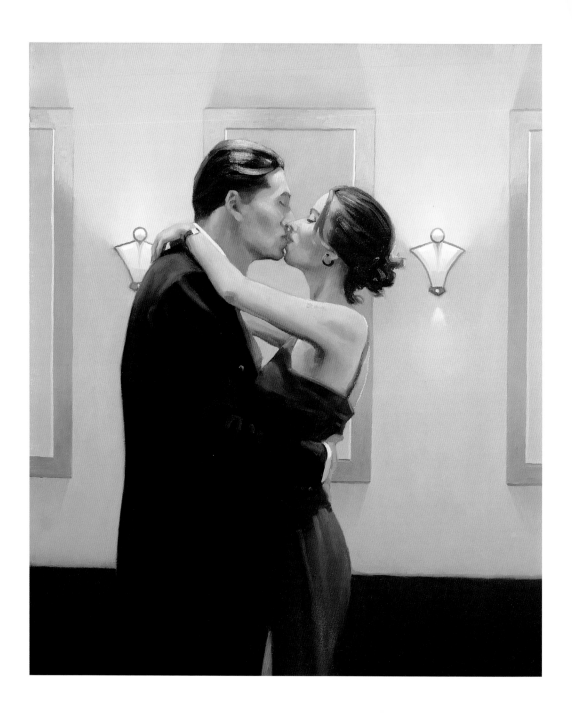

Betrayal – The First Kiss

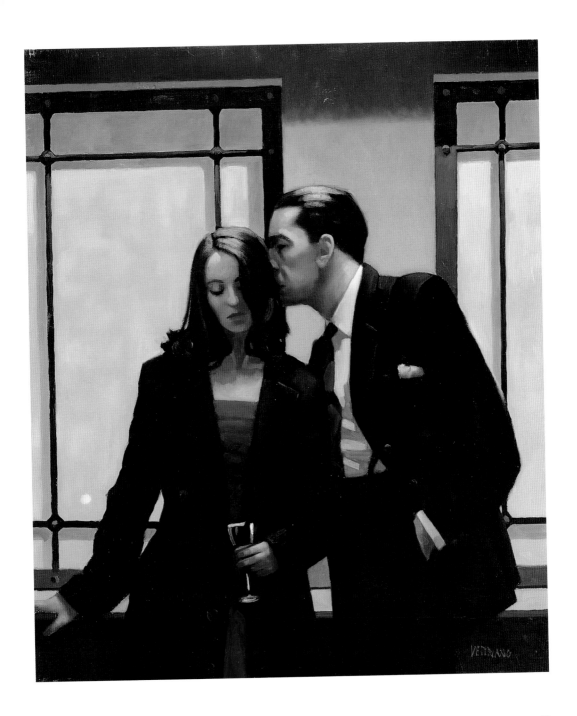

Contemplation of Betrayal

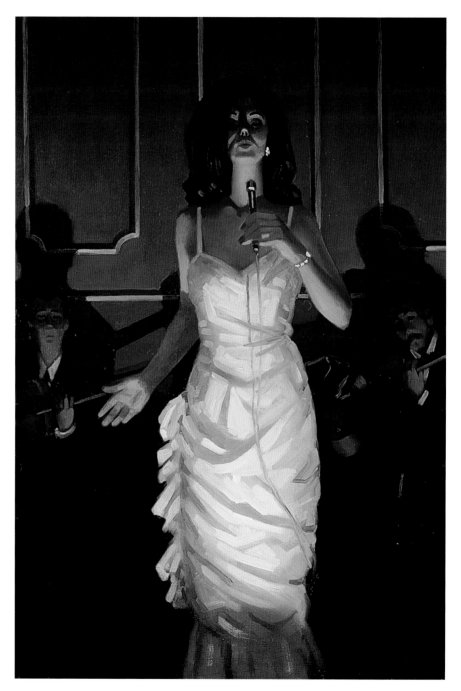

The Jazz Singer

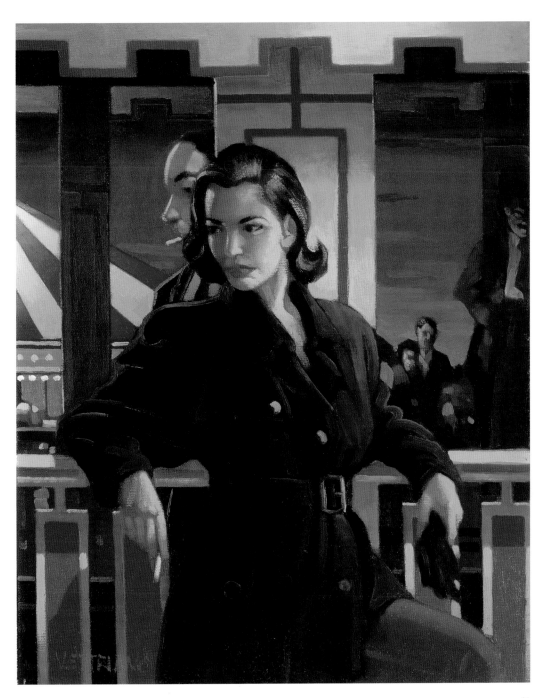

The Main Attraction

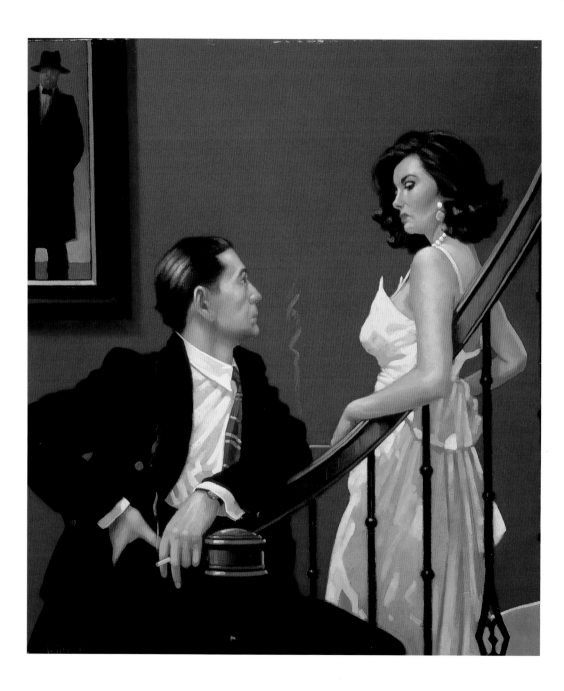

Shades of Scarlett

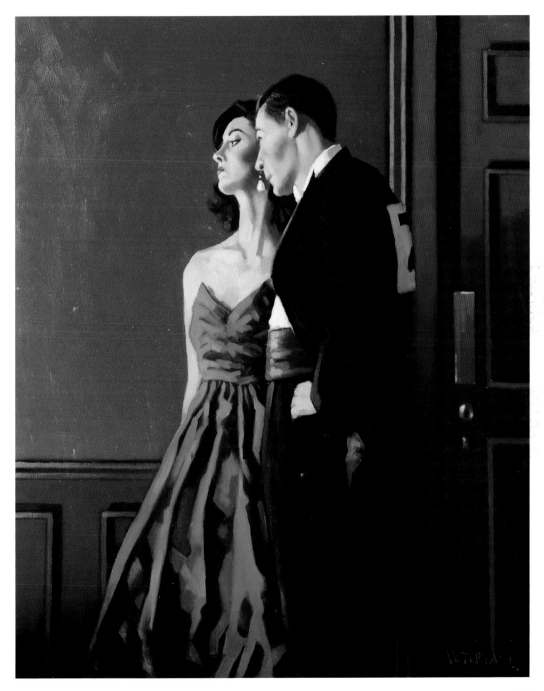

Next Up

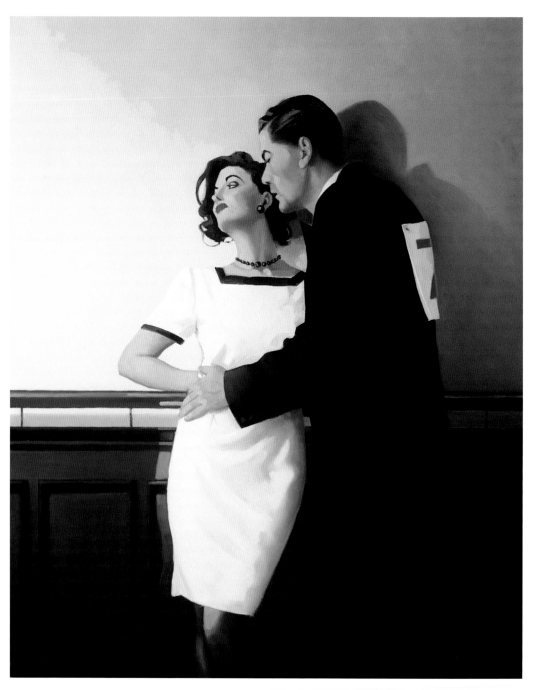

Dancer Number 7

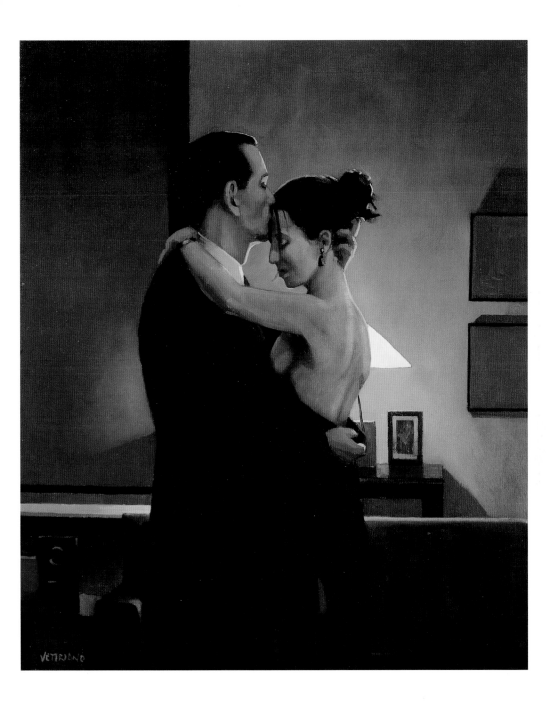

Betrayal – No Turning Back

Waltzers

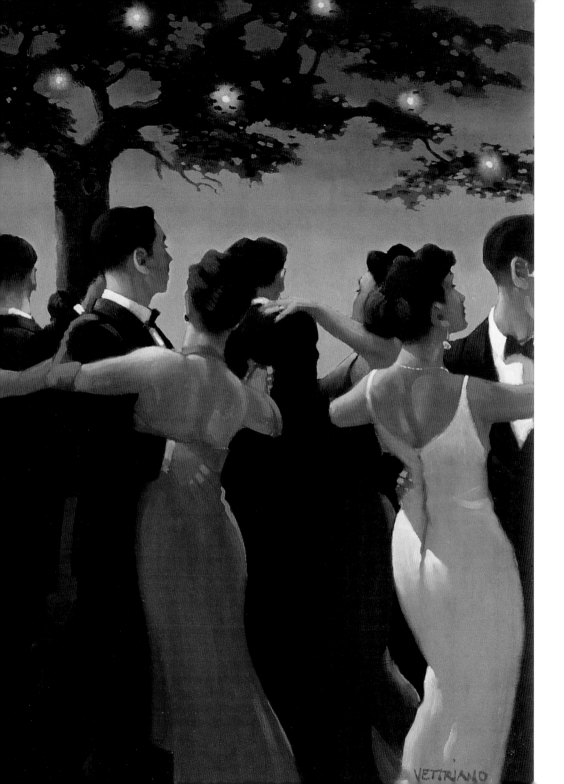

Tango Dancers

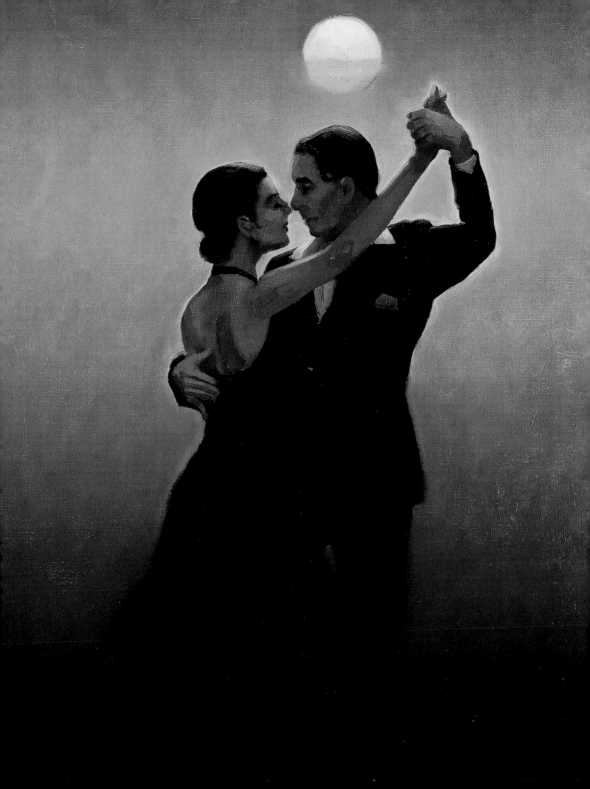

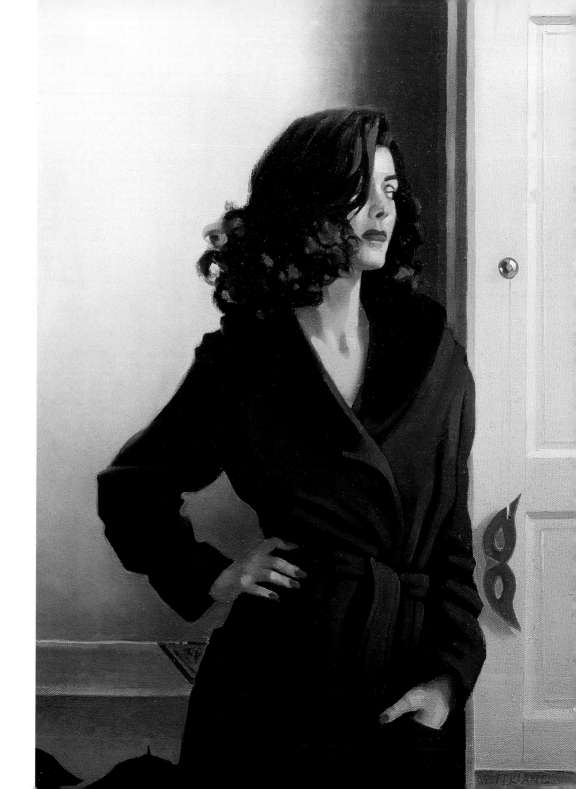

Dressing to Kill

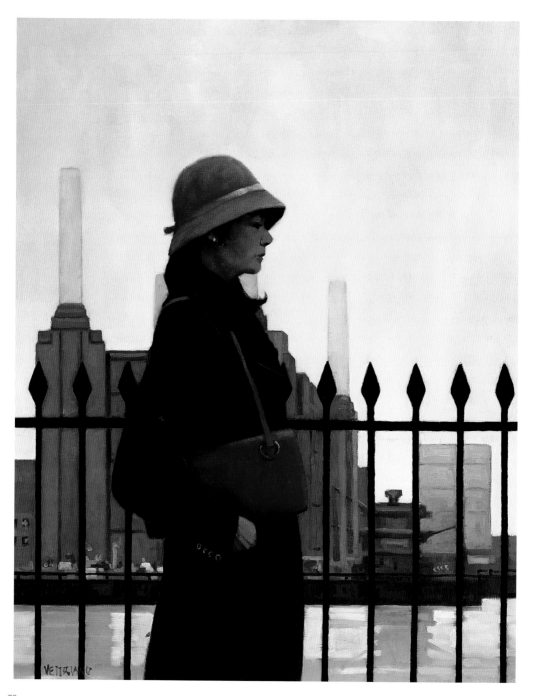

Just Another Day

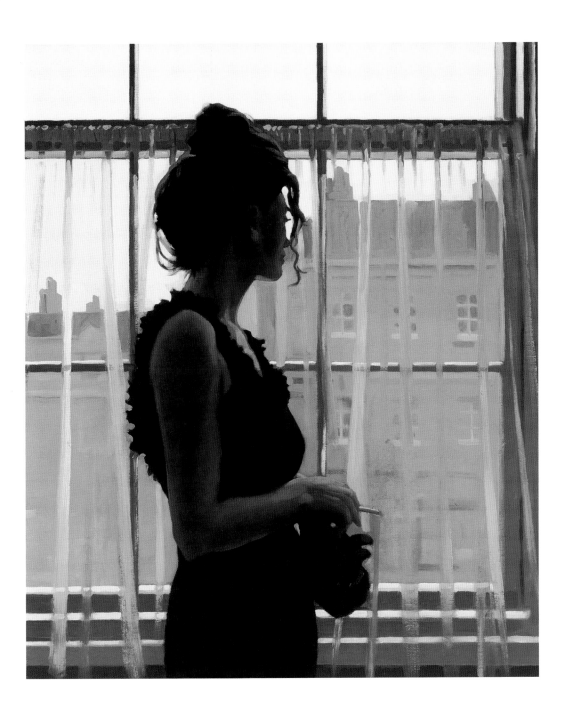

Yesterday's Dreams

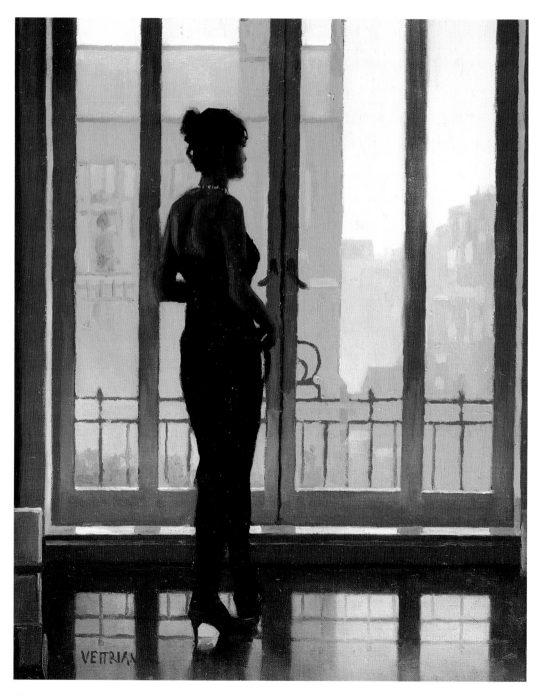

Portrait in Silver and Maroon

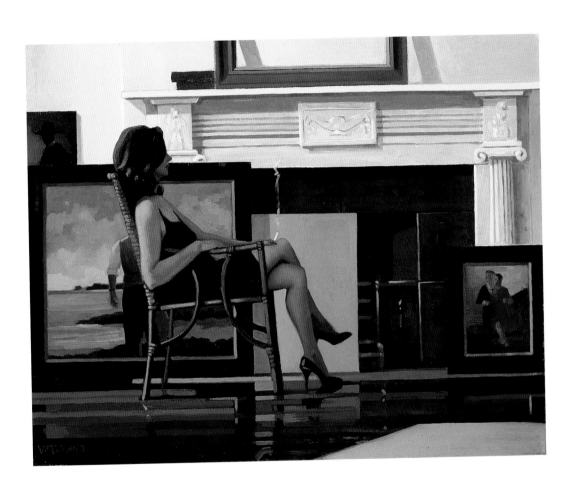

The Model and the Drifter

A Valentine Rose

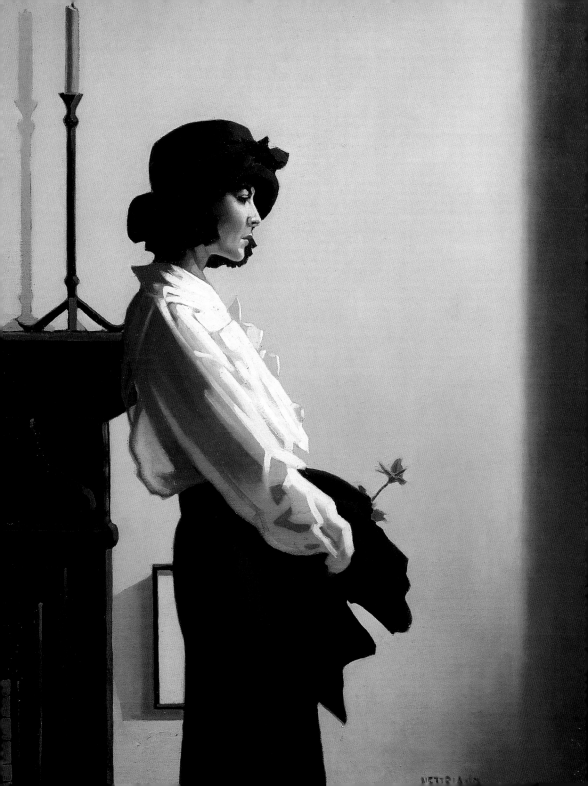

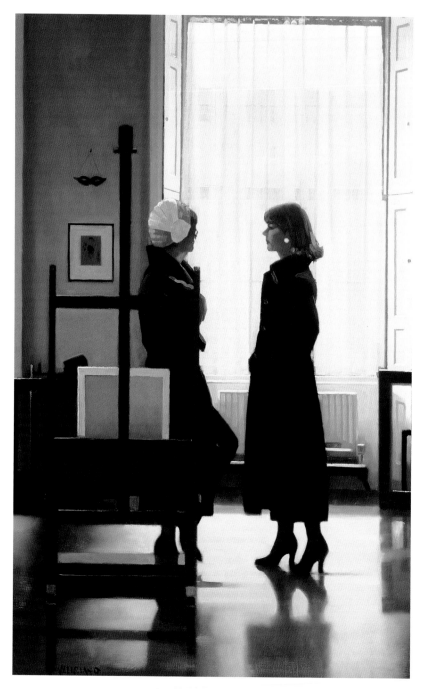

Models in the Studio II

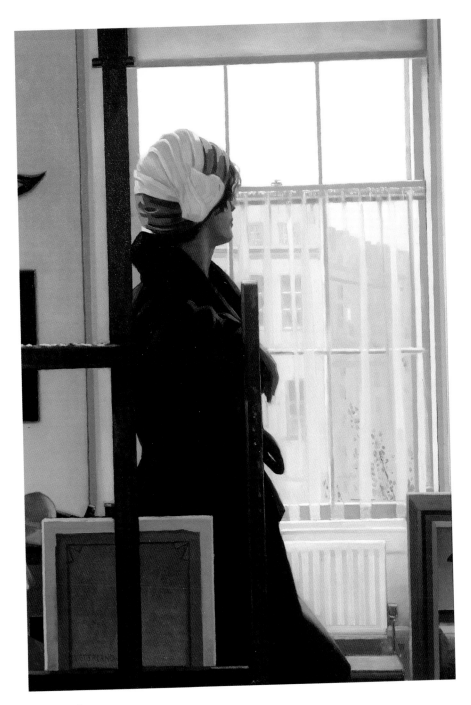

Tomorrow Never Comes

Winter Light and Lavender

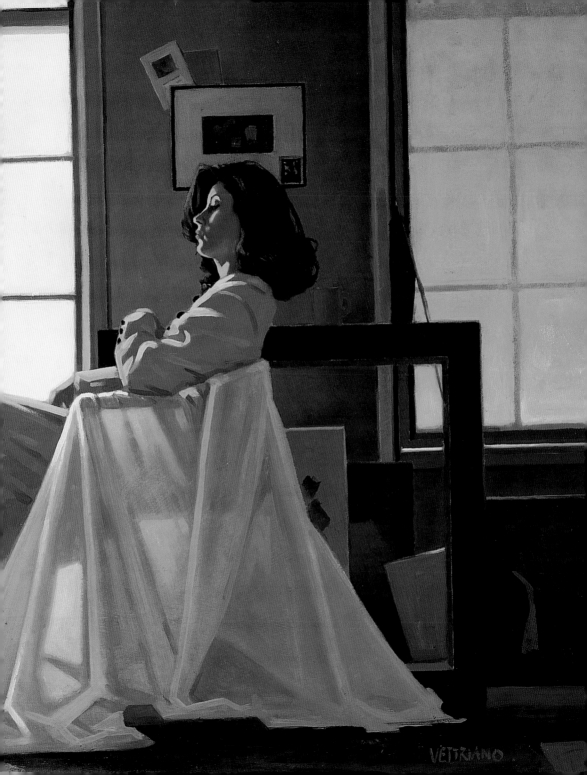

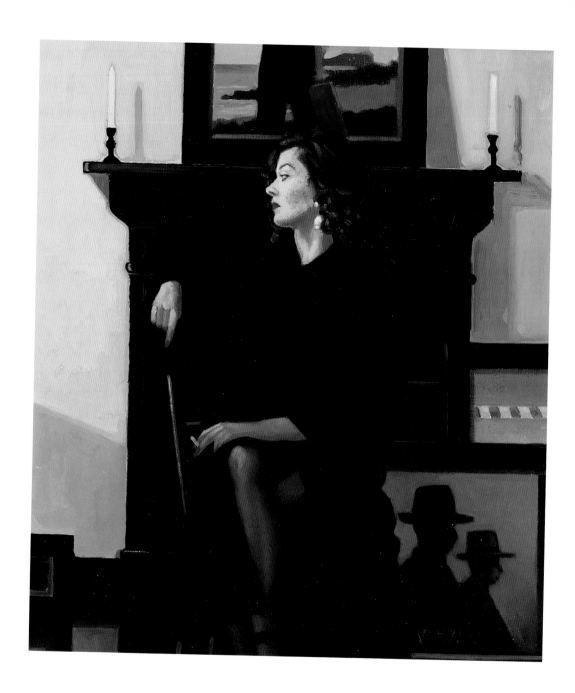

Model in Black

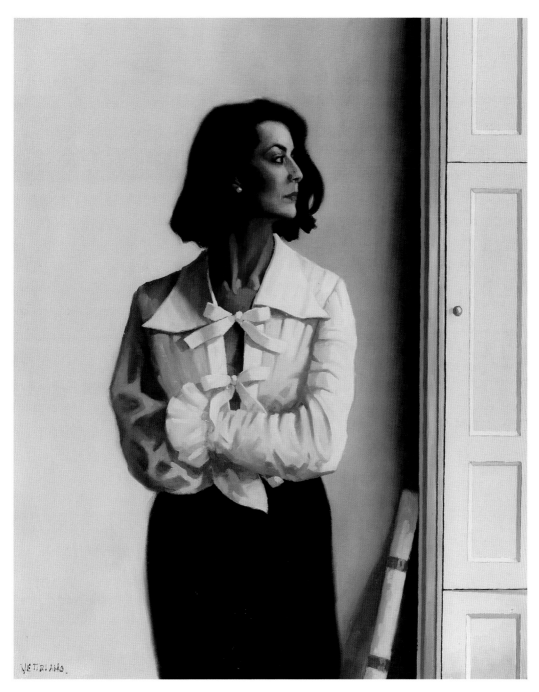

Edinburgh Afternoon

Model in White

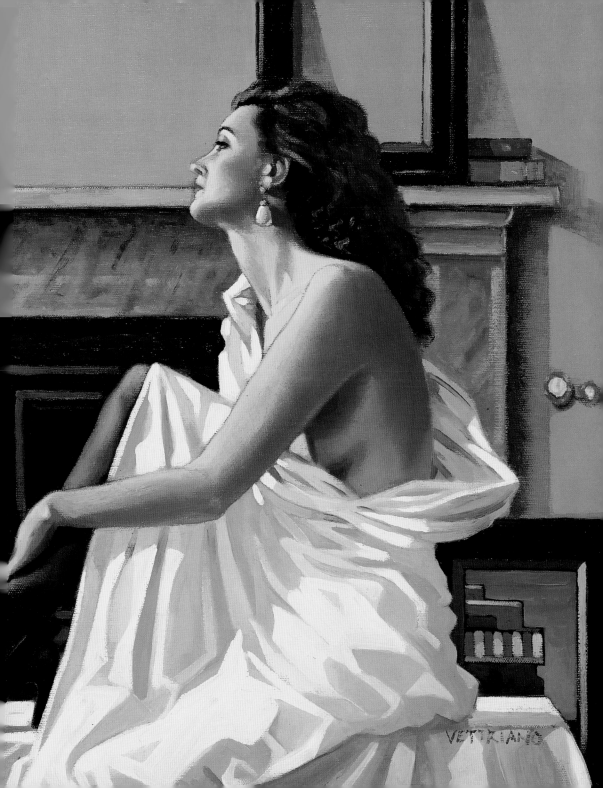

One Moment in Time

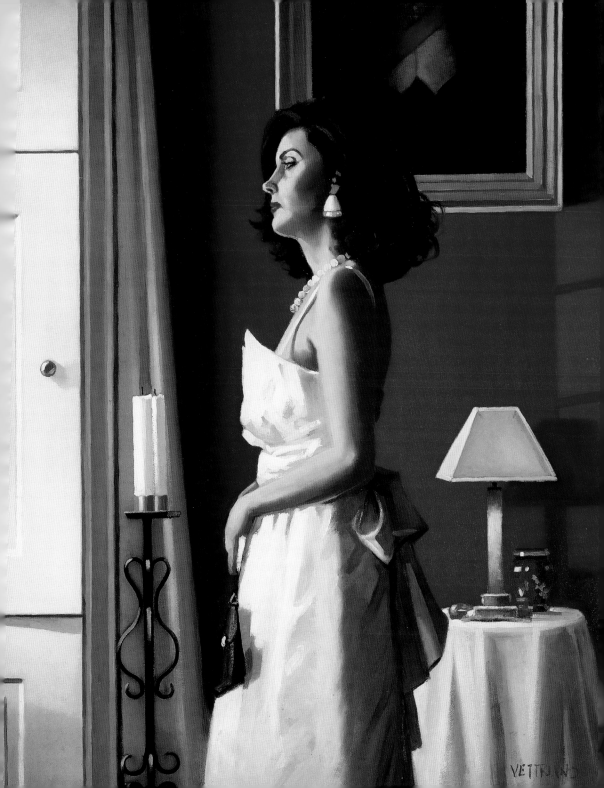

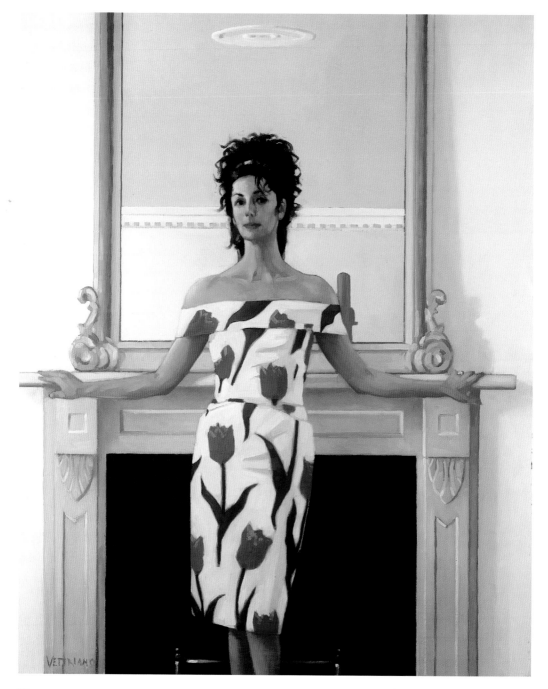

The Tulip Dress

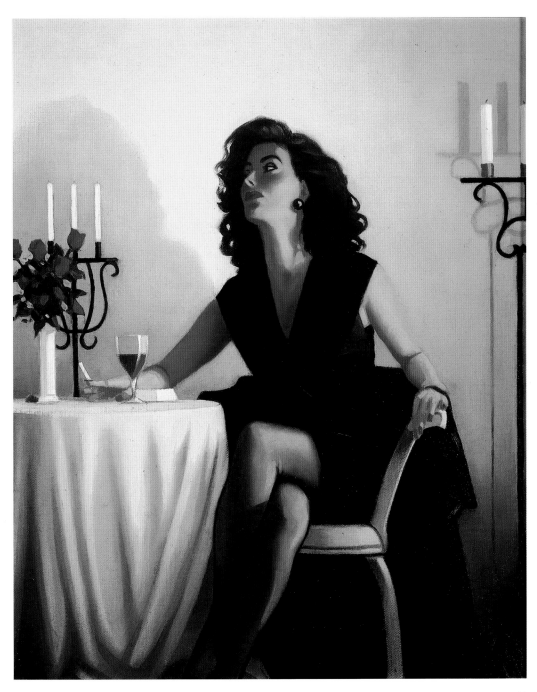

Table for One

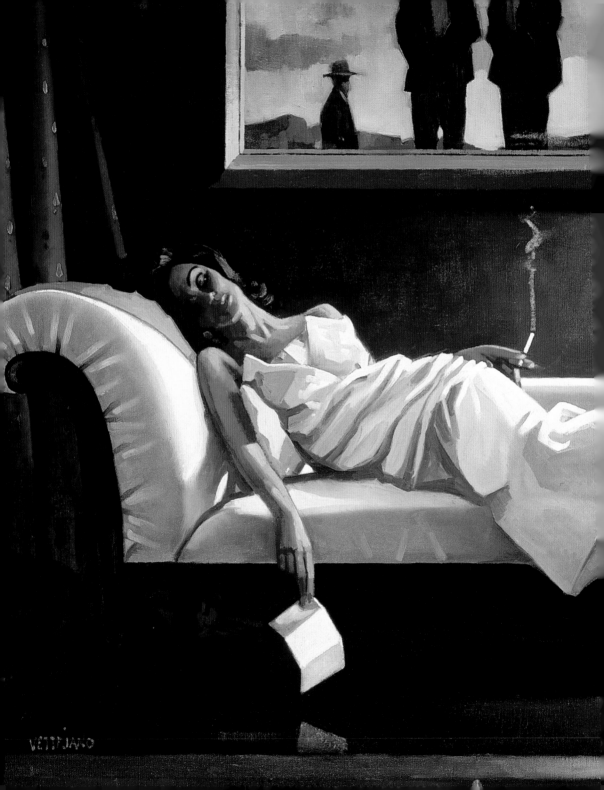

The Letter

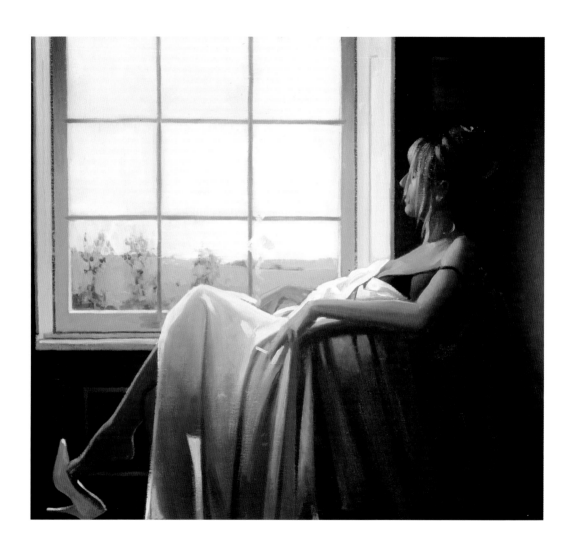

Drawing Room, Easterheughs

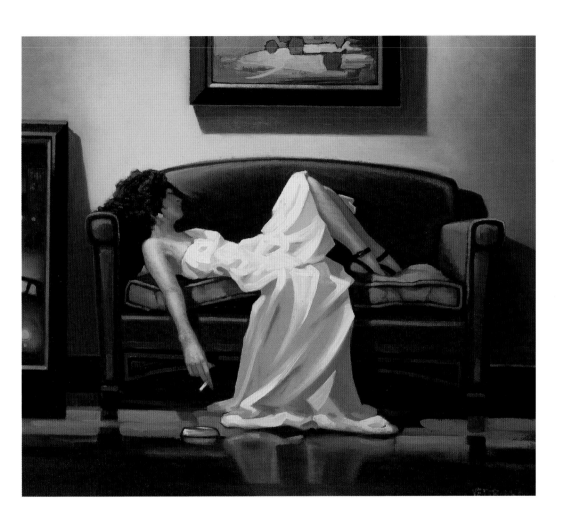

After the Thrill is Gone

Baby, Bye Bye

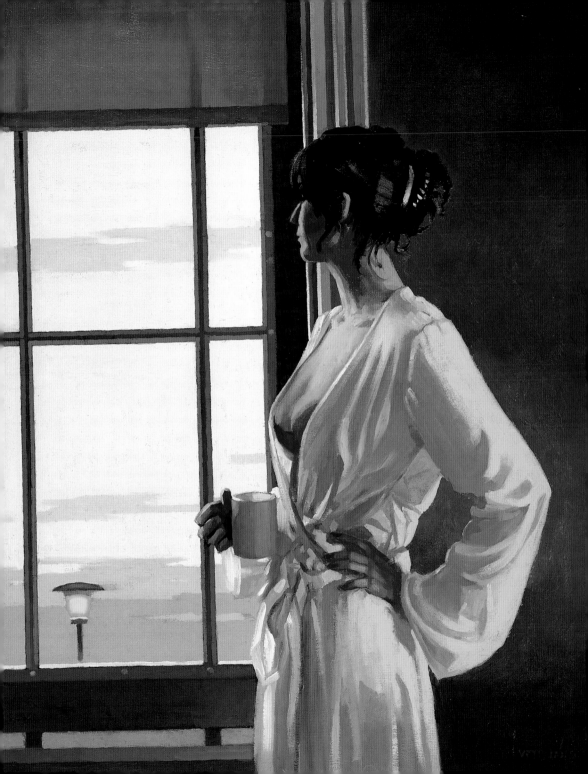

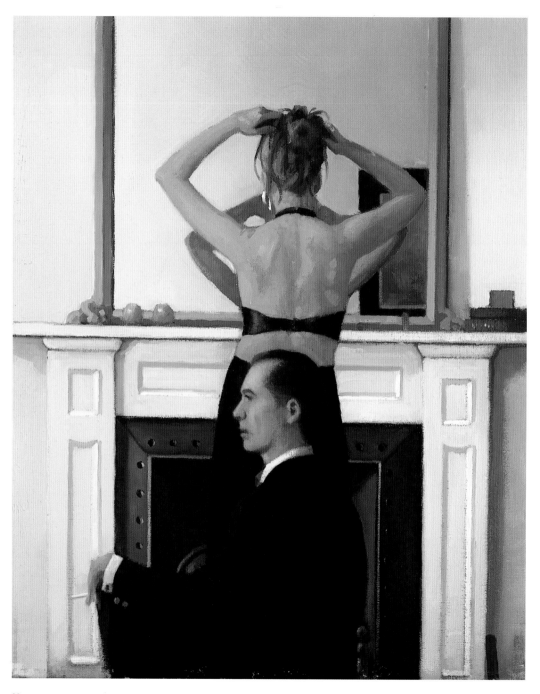

Models in the Studio (Study)

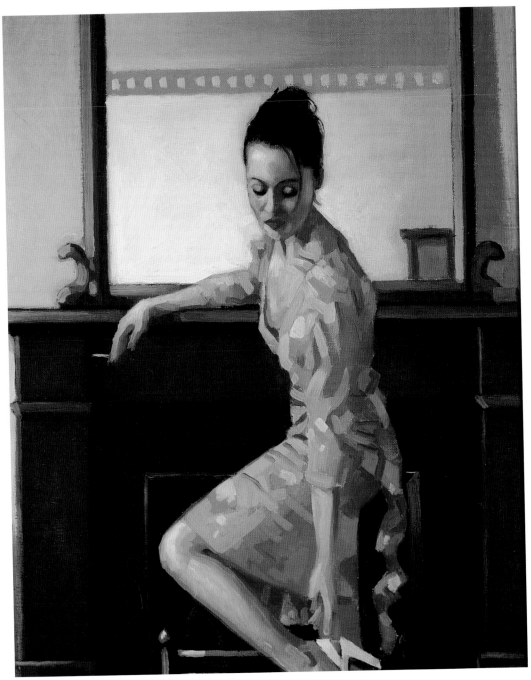

Model in Westwood

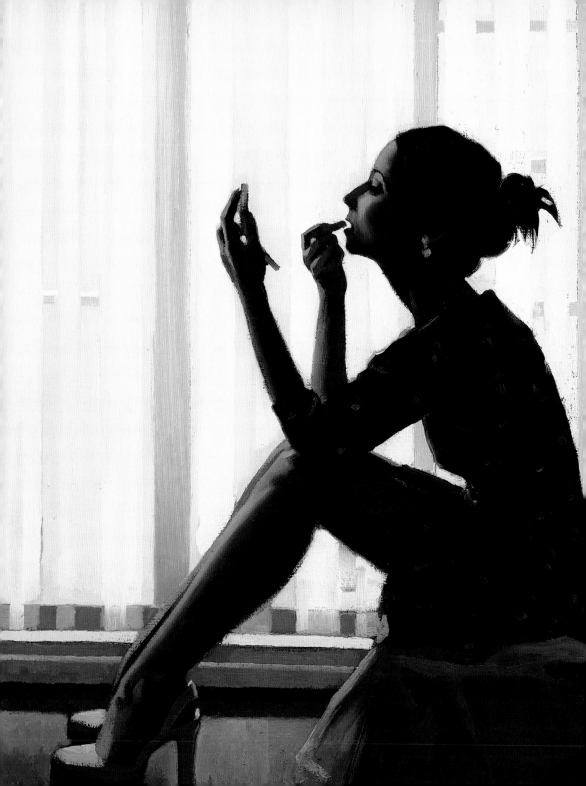

Only the Deepest Red

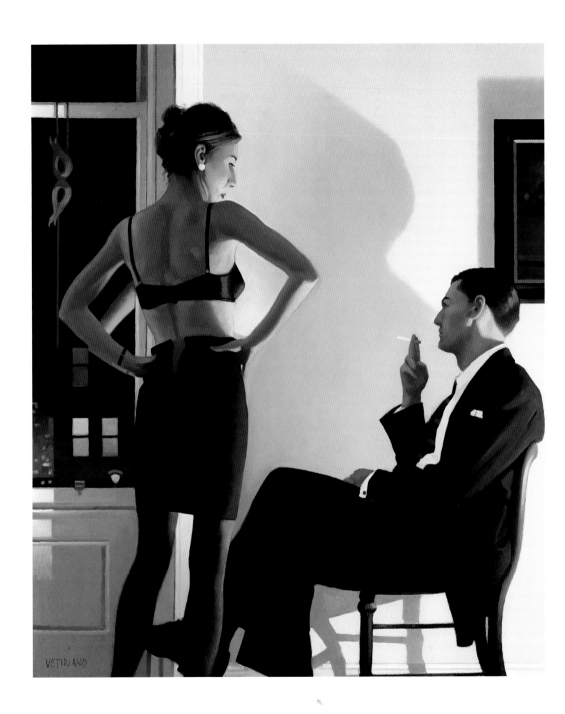

Night in The City

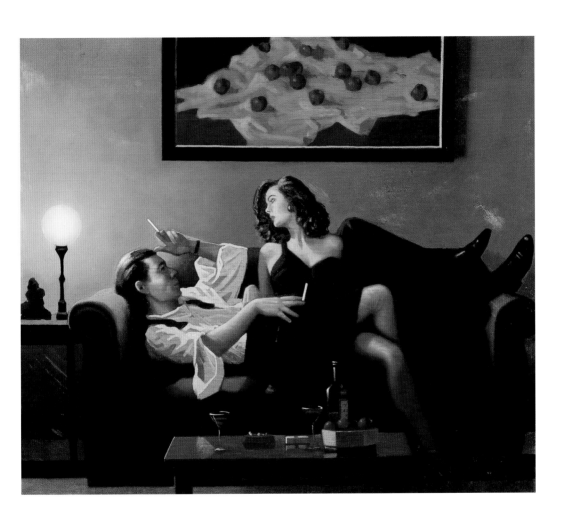

After Midnight

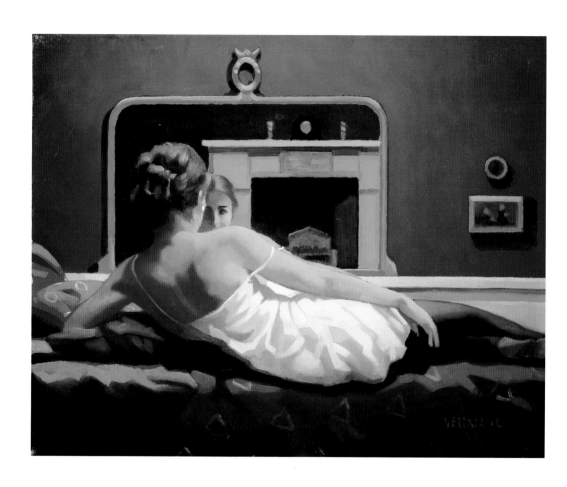

Queen of Vanities

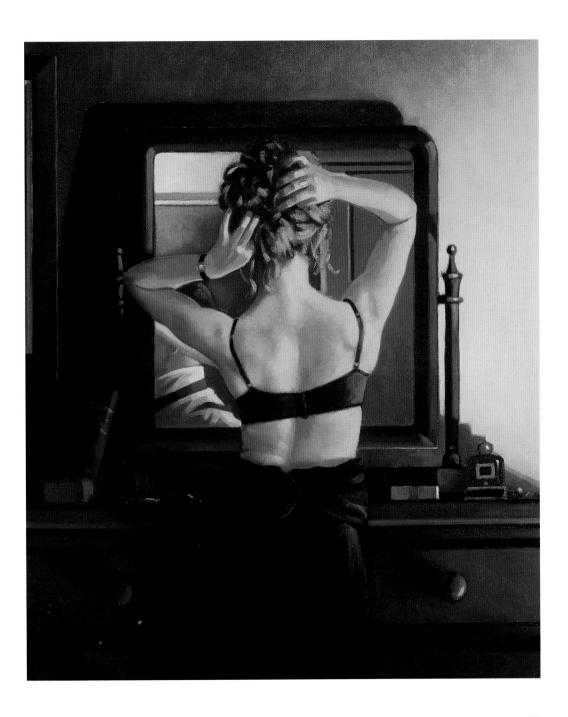

Rooms of a Stranger

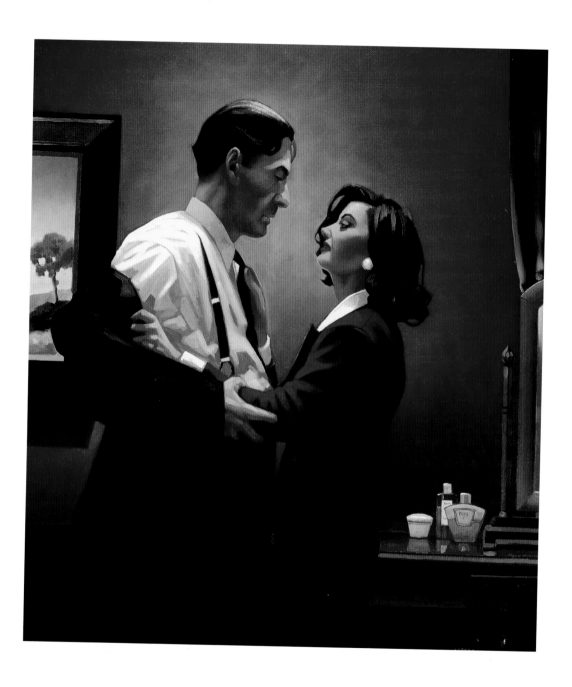

Welcome to My World

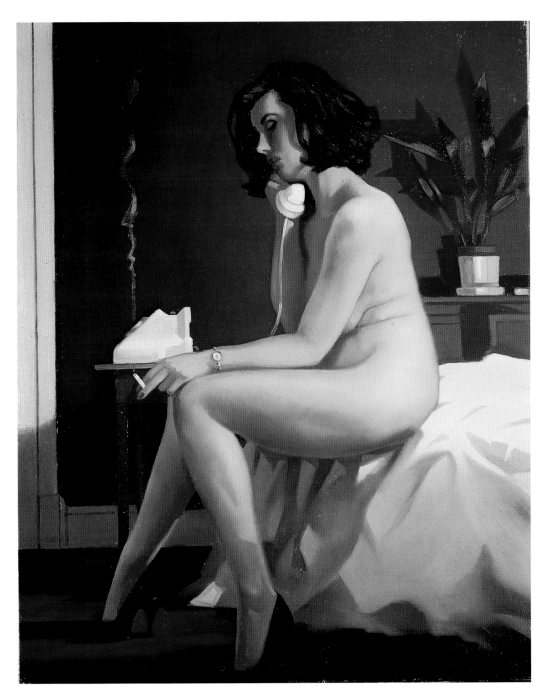

The Arrangement

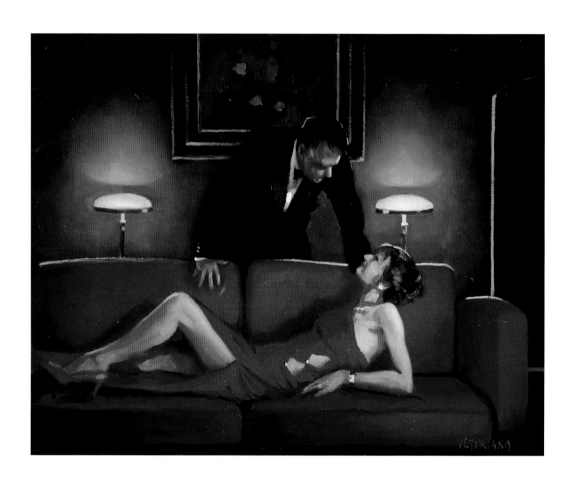

The Look of Love

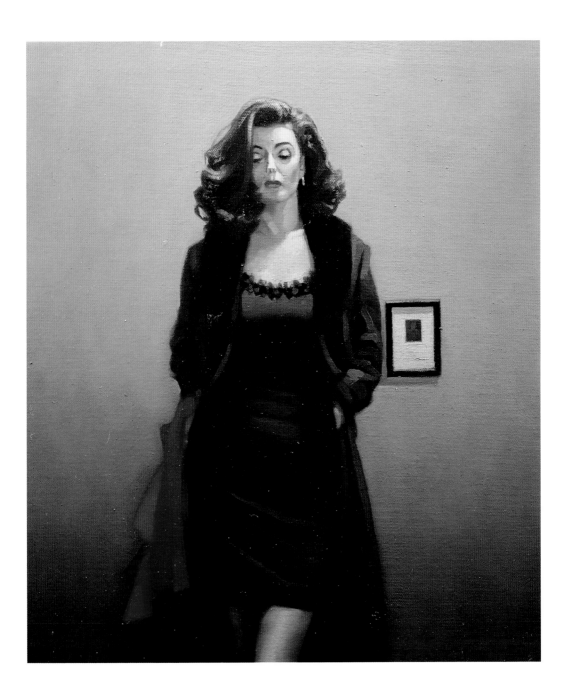

The Mark of Cain

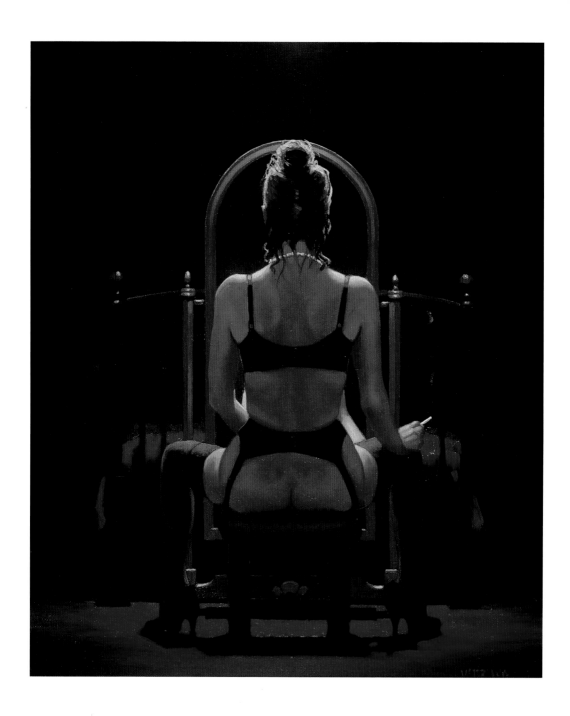

Mirror, Mirror

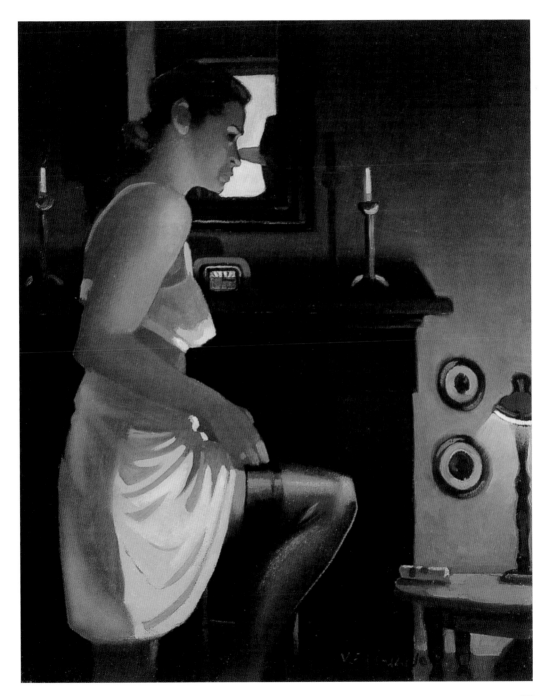

The White Slip

Index of paintings

First published in Great Britain in 2009
by Pavilion

An imprint of the Anova Books Company Ltd
10 Southcombe Street, London W14 0RA

Paintings © Jack Vettriano
Design and layout © Pavilion
Designed by Martin Hendry
Jacket Design by Georgina Hewitt

A CIP catalogue record for this book is available
from the British Library.

ISBN 978 1 86205 855 2

Printed and bound by 1010 Printing International Ltd,
China

10 9 8 7 6 5 4 3 2 1

This book can be ordered direct from the publisher.
Please contact the Marketing Department. But try
your bookshop first.

www.anovabooks.com

For further information on Jack Vettriano please visit
www.jackvettriano.com